MILTON KEYNES

THROUGH TIME

Marion Hill

AMBERLEY PUBLISHING

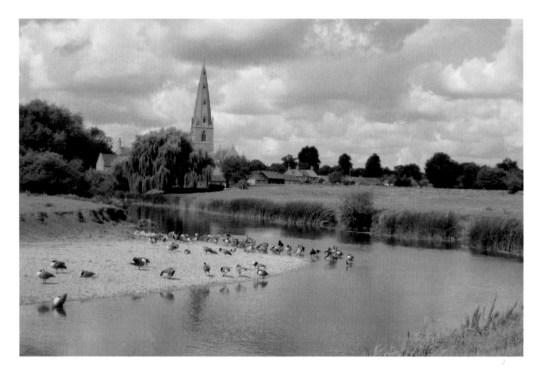

View of Olney's ancient river meadows, 2009, in the Milton Keynes Borough's most northerly town, around ten miles from the city centre (photograph by Bob Hill).

Front cover top: Photograph taken by H. Bartholomew of Great Linford, *c.* 1910 (MK Central Library).
Front cover bottom: Great Linford Waterside Festival, 2008 (photograph by Jamie Slee).
Back cover top: Newport Pagnell from North Bridge, 1910 (photograph courtesy of Newport Pagnell Historical Society).
Back cover bottom: Newport Pagnell from North Bridge, 2009 (photograph by Bob Hill).

First published 2009

Amberley Publishing Plc
Cirencester Road, Chalford,
Stroud, Gloucestershire, GL6 8PE

www.amberley-books.com

Copyright © Marion Hill, 2009

The right of Marion Hill to be identified as the
Author of this work has been asserted in accordance
with the Copyrights, Designs and Patents Act 1988.

ISBN 978 1 84868 623 6

British Library Cataloguing in Publication Data.
A catalogue record for this book is available from
the British Library.

Typeset in 9.5pt on 12pt Celeste.
Typesetting by Amberley Publishing.
Printed in the UK.

Contents

Acknowledgements 4

Introduction 5

CHAPTER 1 Along the Borough Boundary 7

CHAPTER 2 Getting Around 25

CHAPTER 3 Working Life 43

CHAPTER 4 Meeting Points 61

CHAPTER 5 Changing Places 79

Acknowledgements

Most of the older images have come from the massive photographic archives of two of the city's most significant repositories. Firstly, the Living Archive (www.livingarchive.org.uk); of particular importance is the early 1970s archive donated by Ian Cawthorne showing the area before the start of the new city. Living Archive's vast collection of people's reminiscences has also been a significant resource. Special thanks for their expertise to Zena Flinn, Leon Russell and Eve Watson; to the Thursday Volunteers who helped scan 100-odd photos; and to Cheryl Butler of the Discover Milton Keynes Showcase in CMK. Secondly, Milton Keynes Central Library (www.milton-keynes.gov.uk/library_services); special thanks for their help and support to Ruth Meardon and her colleagues of the Local Studies Section.

Thanks also to the following organisations for their ease of access: The Parks Trust, Milton Keynes (www.theparkstrust.com); Railcare, Wolverton (www.railcare-uk.com); the Victoria and Albert Museum, London (www.vam.ac.uk).

Particular thanks for their interest and active help to: Kevin Adams of Castlethorpe (www.kevadams. co.uk); Deborah Cooper of the Great Linford Waterside Festival (www.watersidefestival.co.uk); Paul Cox of the Woburn Sands Collection (www.mkheritage.co.uk/wsc); Geoff Dawe of Milton Keynes Village/Two Villages Archive Trust (www.mkheritage.co.uk/tvat); Shane Downer, Senior Heritage Officer of Milton Keynes Council (www.milton-keynes.gov.uk/heritage); Audrey Edwards of Ravenstone (www.ravenstone. org.uk); Nicholas Fuller of Stony Stratford (www.mkheritage.co.uk/mkm/stonystratford); Simon Greenish of Bletchley Park (www.bletchleypark.org.uk); Don Hurst of the Newport Pagnell Historical Society (www. mkheritage.co.uk/nphs); Roger Kitchen of the Secret Garden, Wolverton (www.wolvertonsecretgarden. co.uk); David Lock of Calverton Manor Farm (www.davidlock.com); Sue Malleson of Bow Brickhill (www. bowbrickhill.com); David Muston of the Milton Keynes Heritage Association (www.mkheritage.co.uk); Sharon Paulger of InterAction-MK (www.interactionmk.org.uk); Anne Robinson, photographer for the Parks Trust Milton Keynes (www.theparkstrust.com); Lee Scrivens of the MK Dons Football Club (www.mkdons. com); Tony Seward of the Cowper and Newton Museum, Olney (www.mkheritage.co.uk/cnm); Jamie Slee, photographer for Great Linford Waterside Festival (www.watersidefestival.co.uk); Kay Turrell of the Sherington Historical Society (www.mkheritage.co.uk/shhs); Henk van Aswegan of the Milton Keynes City Discovery Centre (www.mkcdc.org.uk); and to Bob Hill, for photographing nearly all the modern images.

The following texts were also sourced:
Bucks Standard local history articles by Prof Richard Britnell, former resident of Lavendon, 1964
'Clutch Club' websites — 'Computer Literacy and Understanding through Communicating History' — a millennium project for website creation by parents and children in sixty schools within thirty miles' radius of Milton Keynes, run by Living Archive and the Open University (http://clutch.open.ac.uk/ schools)
Hanslope and District website (www.mkheritage.co.uk/hdhs)
Kelly's Directory 1933
Milton Keynes, Image and Reality, Bendixson and Platt, 1992
Milton Keynes Museum website (www.mkmuseum.org.uk)
Olney and District Historical Society website (www.mkheritage.co.uk/odhs)
Rectory Cottages Bletchley website (www.mkheritage.co.uk/rct)
Stoke Goldington website, with text written by Derek George (www.mkheritage.co.uk/sga)
The Plan for Milton Keynes, (2 vols.), MKDC, 1970

Introduction

Milton Keynes is the nation's last 'new town' and first new city to be designated under the 1946 New Towns Act. It came into being on 23 January 1967. Around 40,000 people were living in that part of North Buckinghamshire at the time, in 13 villages and 3 towns.

The government-appointed Milton Keynes Development Corporation had been entrusted with developing a city that was self-sufficient and sufficiently well-appointed to become a regional centre. The challenge was to transform forty square miles (just over one hundred square kilometres) of gently undulating farmland, which was somewhat prone to flooding and with, as was discovered, a human and geological heritage going back some 150 million years.

By the time the corporation was wound up in 1992, 2,660 new businesses had set up in the city providing 80,000 new jobs for a population that had increased four-fold. Citizens were able to drive on 21 major grid roads crossing the city, cycle along 150 miles of safely segregated Redways, spend leisure time in 4,000 acres of protected parkland — 20 per cent of the city area — and consequently experience a 30 per cent increase in wildlife attracted in part by the 20 million trees and shrubs that had been planted for the new city.

Residents were also able to enjoy not only many protected characteristics of the original villages and towns but also a unique heritage that the city's development had uncovered in digging foundations for its new communities. From prehistoric hunters and settlers through the invasions of Romans, Danes, Saxons and Normans, to pioneers of stagecoach, canal, railway and motorway travel — Milton Keynes is a precious microcosm of English history.

This heritage was enormously enhanced when the city's elected Unitary Authority came into being in 1997 and trebled the area to be directly under its auspices: the Milton Keynes Borough incorporates an area of 120 square miles (310 square kilometres) — around the size of the island of Malta.

The boundary of Milton Keynes Borough is over 60 miles long (about 90 km) — as far as it is to travel from central Milton Keynes to central London. It flanks three of the borough's six towns[1], its border coming within a mile of half the twenty-eight villages that are outside

the designated new city area. It traverses twice not only a 'Great' meandering river[2] and a 'Grand' old canal[3] but also two of the nation's busiest modern north-south routes, by road and by rail[4]. It encloses the northernmost finger of an ancient Royal Shire[5] characterised by centuries of farming. It is the girdle that already encompasses the homes of nearly a quarter of a million people, which is set to increase to 350,000 by 2031 when Milton Keynes will be the nation's tenth largest urban area.

It is this boundary line that traces the first chapter of a unique journey through time where the lives and experiences of people in the Milton Keynes area can be relished — and cherished.

[1] The towns of Bletchley, Stony Stratford and Woburn Sands are on the borough's border; Newport Pagnell, Olney and Wolverton are within it
[2] The River Great Ouse
[3] The Grand Union Canal — known formerly as the Grand Junction Canal
[4] The M1 Motorway and the West Coast Railway from London to Scotland
[5] Buckinghamshire's name has been recorded since the twelfth century.

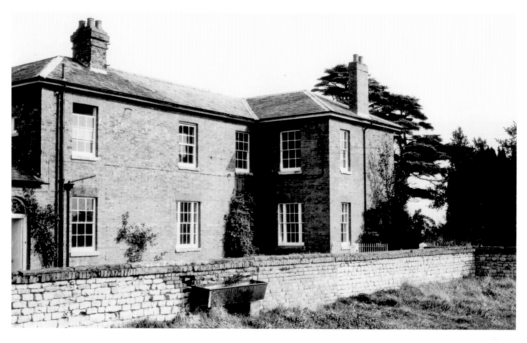

Stacey Hill Farm, Wolverton, 1971
Stacey Hill Farm was built in 1847 as a model farm, owned by the Radcliffe Trust which helped to fund Oxford's John Radcliffe Hospital. The farm twice hosted the men's English National Cross Country Championship, the oldest event of its kind in the world. Milton Keynes Museum was founded at the farm in 1973 when local people collected items from farms and factories closing down to make way for the new city's development.

Starting in the West at Calverton Manor Farm

The borough's westernmost village, Calverton, is bordered by the River Great Ouse, with Upper, Middle and Lower Wealds its scattered component parts. It is recorded in the 1086 Domesday Book as 'Calvretone'. These rural views of Manor Farm belie a seventeenth-century murder and the subsequent hanging of a Stony Stratford butcher at Galley Hill, nearby secret receiving stations operating during the Second World War and possibly the oldest — 1,200-year-old — residence in the borough.

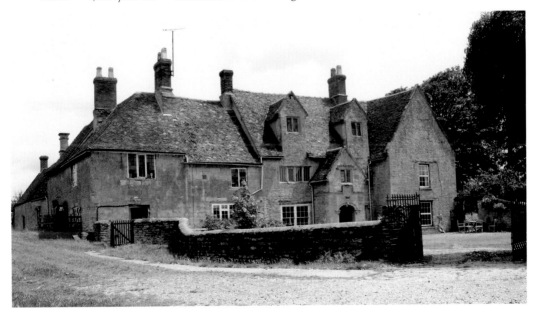

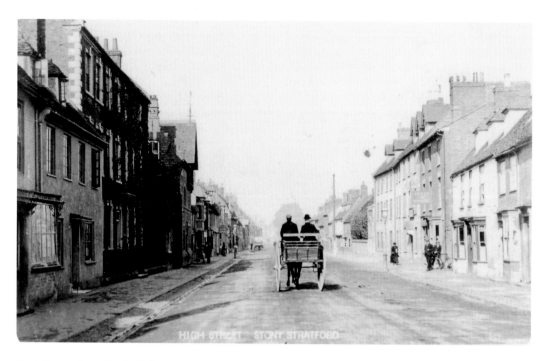

Past Stony Stratford High Street...

The Milton Keynes Boundary Walk starts at the Calverton Road riverside picnic site in Stony Stratford and heads north past the old Mill Race, across the town's Roman Watling Street (High Street) with its centuries-old coaching inns, which include the most famous of all, The Cock and The Bull. The Walk meanders with the River Great Ouse past Toombs Meadow and the floodplain forest of white willows and willow herb in the new city's Ouse Valley Park.

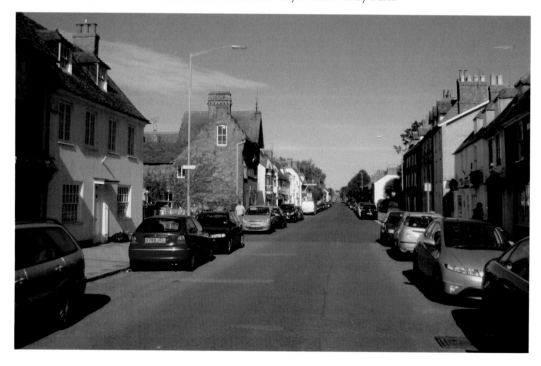

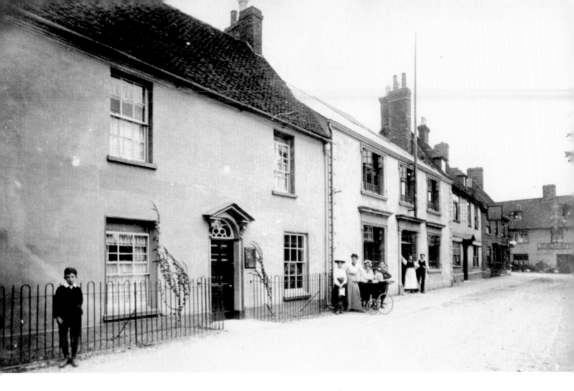

... and Stony Stratford Market Square

'At Stony Stratford they do rest tonight...' (Shakespeare's *Richard III,* Act 2, Scene IV*).*
Unlike these children in Market Square, twelve-year-old Edward V and his brother met
an untimely end in the Tower of London after staying at the town's Rose and Crown Inn
(*c.* 1483). Stony held its first market 800 years ago; welcomed over 30 stagecoaches daily
300 years ago; survived two disastrous fires 250 years ago; and for 65 years, from 1860,
accommodated the world-famous boat-building works Hayes.

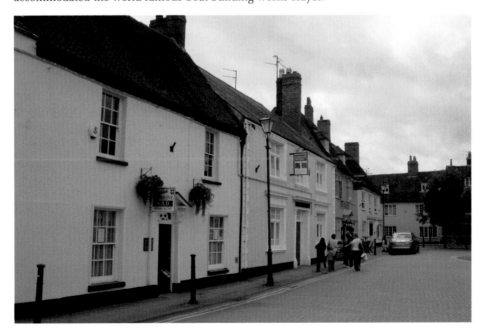

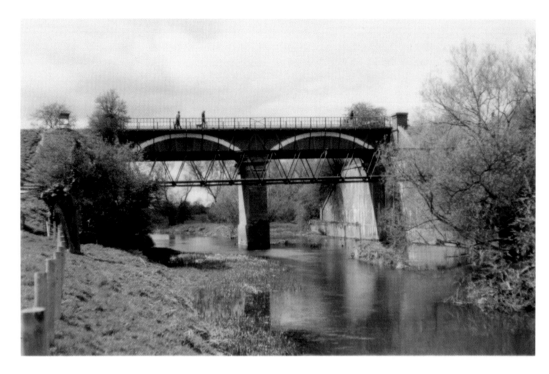

Crossing Old Wolverton's Iron Aqueduct

Passing the site of Wolverton's medieval village, the borough boundary crosses the Grand Union Canal at the 'ackeyduck', a 200-year-old iron aqueduct, one of the nation's first and near its newest, built in 1991 over the city's V6 Grafton Street. At thirty metres long, the old aqueduct is as wide as the River Great Ouse that it spans (four and a half metres); flanked by 'cattle-creep' tunnels, it keeps the canal ten metres above the river, effecting the work of nine locks.

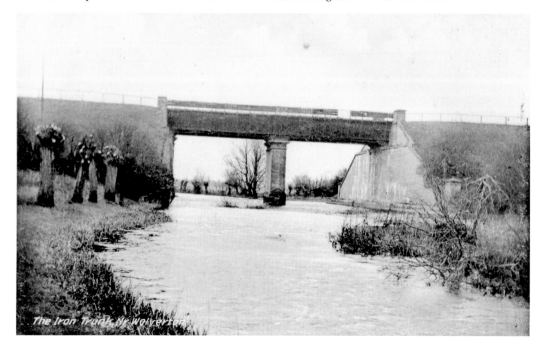

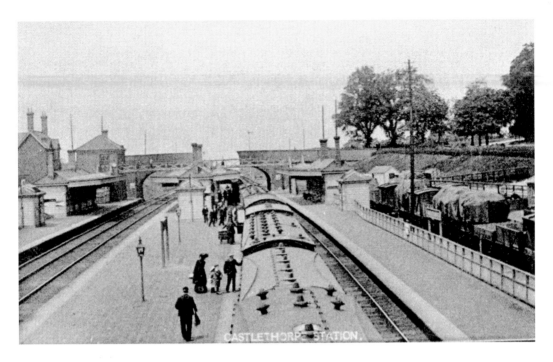

North-West to Castlethorpe

Leaving the city boundary at the aqueduct, the borough border tracks the River Tove along the West Coast Main Line running through the historic village of Castlethorpe — whose eponymous origins are evidenced by only a mound and yet tales endure from the times of King John. The village is separated from Northamptonshire by the Tove and is linked by canal towpath to Cosgrove. It had its own train station until September 1964 when, to residents' outrage, it was closed down.

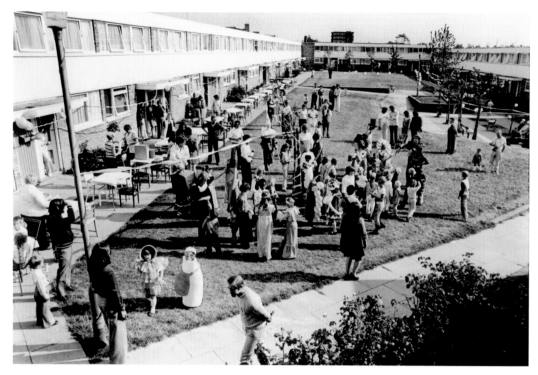

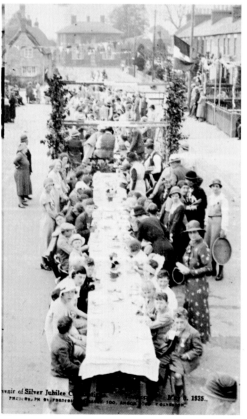

Souvenir of Silver Jubilee C... May 6, 1935.
PHOTOGRAPH BY PHOTOGRAPHIC ... 100, ANSON ... WOLVERTON.

At Hanslope in the North-West...
Like Bletchley in the South-East

The celebrations above on Bletchley's Lakes Estate make interesting comparisons with one forty years earlier (1935) at Hanslope. From the borough's westernmost edge you can see Hanslope's famous church spire, soaring 55 metres (180 feet) above cornfields. South-east lies Hanslope Park (HM Government Communications Centre), formerly the manorial estate where, in 1904, Squire Watts was mysteriously murdered. In Long Street, Lace Cottage housed a school for children as young as five learning 'one hour's reading a day and seven hours' lace-making'.

Northwards to Ravenstone

Over the M1 between junctions 14/15, the boundary skims the medieval royal hunting ground of Salcey Forest. Across the Northampton-Newport Pagnell road, the fields beyond once-grand Eakley Lanes give way to the still-lush greenery of Ravenstone Great Wood, marking the Northamptonshire border. Ravenstone was the victim of a terrible fire in 1897, reported even in the *New York Times*: 'More than half the village... has been destroyed by fire. The flames consumed forty thatched cottages and rendered 150 people homeless.'

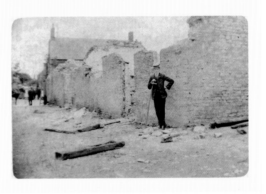

Warrington — the Northernmost Hamlet

The borough's northern boundary passes quiet little farmsteads: Olney Park Farm whose population was eleven in 1861, twenty-one in 1901, four in 1971; Pastures Farm (popular locally at Christmas for free-range turkeys); Warrington Lodge; New Pastures Farm; and Northey Farm at the borough's northernmost tip, around thirteen miles from city centre. The hamlet of Warrington was recorded in the 1086 Domesday Book as 'Wardintone'. Here, new uses of ancient farms — including modern offices — have been invigorated by new city development.

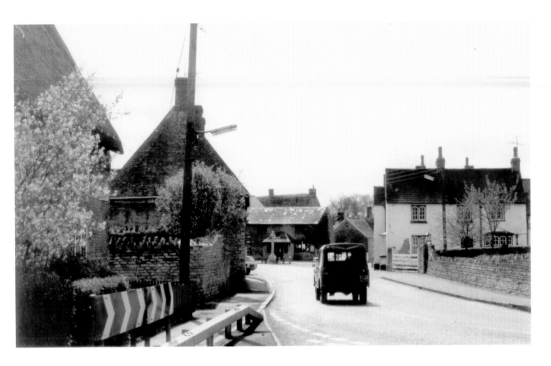

Lavendon — the Northernmost Village

Threeshire and Lavendon Woods represent 'but shreds of the thick curtain of forest that once separated Lavendon from Bozeat and Harrold'. Beyond Lavendon village (seen here) the boundary crosses a 200-year-old turnpike road, the border between Buckinghamshire and Bedfordshire. Tollgate Cottages on one side are (still) in Bucks, and Southfields Farm Cottage on the other is in Beds. Across the Harrold Road, the boundary follows the River Great Ouse, past Snelson whose fourteenth-century manor tenants were called Dragontree.

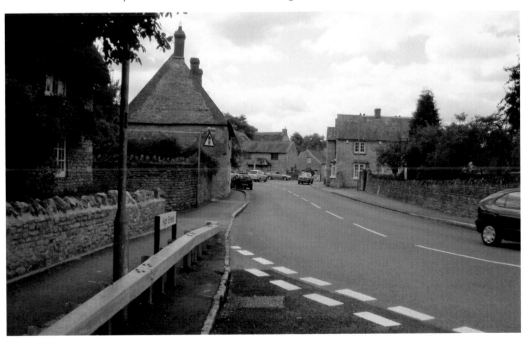

South to Cold Brayfield

The borough boundary curves southwards with the river through Turvey's ancient bridge. Straddling the fields is Cold Brayfield whose earliest known inhabitants settled in Roman times around 1800 years ago. 'Cold' refers to the village's bleak setting on the riverbanks. 'Brayfield' means 'open land by higher ground', referred to in the *Anglo-Saxon Chronicle* of 967 AD as *Bragenfelda*. The manor of Brayfield formerly belonged to the Blossomville family of nearby Newton Blossomville.

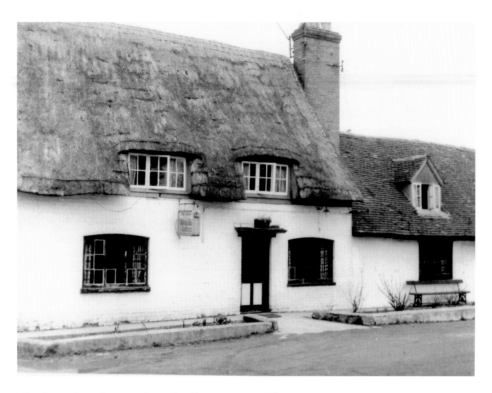

The Swan Inn, Astwood, at the Easternmost Edge

South over the dismantled Midland railway that once had a station at Turvey, the borough border heads for the hamlet of Astwood, which is Anglo-Saxon for 'Eastern Wood', and now the easternmost edge of Milton Keynes Borough. Its ancient church of St Peter has medieval pews, Tudor brasses and a fourteenth-century font. Here, the old Swan Inn, trading since 1685, entertains modern clientele with owner Reg Broomhill's tasty cuisine. The roof-line has been raised to allow for the new porch.

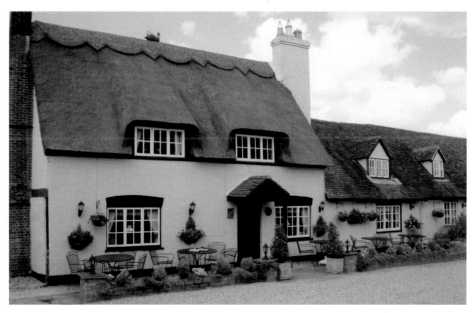

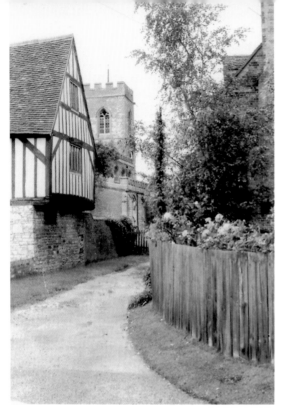

Southwards to North Crawley Church Farm

Once the site of a monastery mentioned in the Domesday Book, St Firmin's twelfth-century church in North Crawley has endured for 800 years — despite a near miss in January 1972 when a USAF FIII jet fighter from Upper Heyford crashed nearby. This caused a maximum-security blockade of the village while police and American officials searched the wreckage. Here, Church Farm shows little change other than careful refurbishment — a mark of many ancient buildings in and around Milton Keynes.

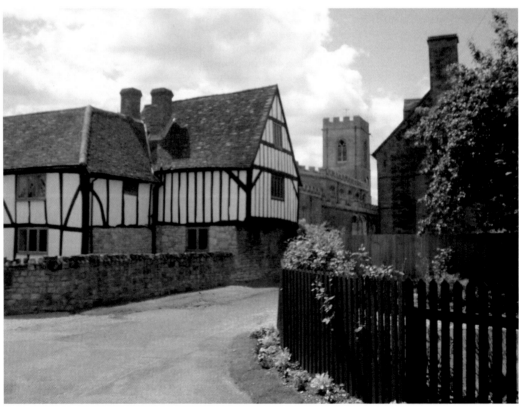

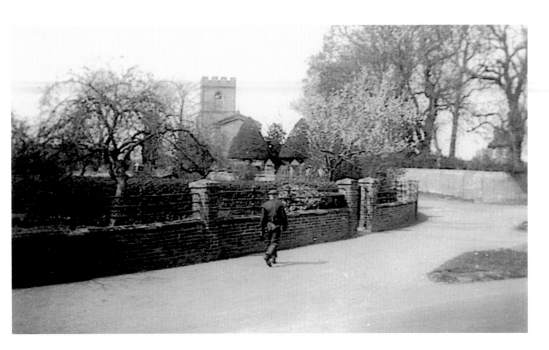

Into the East of the New City — Broughton's St Lawrence's Church

Heading south-west past the Tudor Crawley Grange, the borough boundary comes to Broughton Grounds with its thriving population of birds, foxes and Chinese water deer. The historic village of Broughton, just over the M1, is the centre of a brand new district of the city. The old view of St Lawrence's church is obscured now, but the church still contains remarkable 600-year-old wall paintings with graphic images of 'The Dismemberment of Christ' and 'St George and the Dragon'.

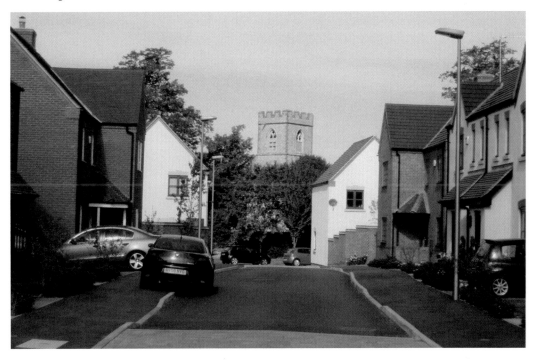

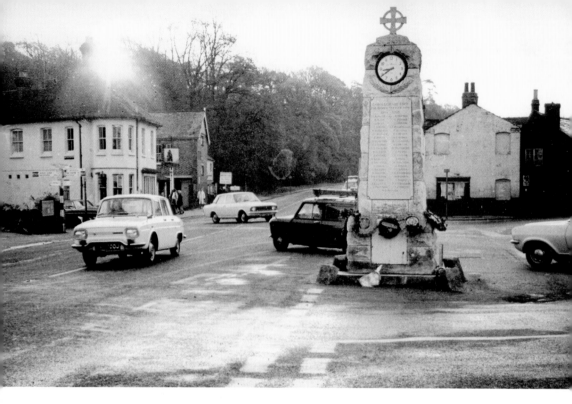

Woburn Sands — Straddling the Borough's Eastern Boundary

Woburn Sands is mainly in the Milton Keynes Borough but the boundary at these crossroads divides it, so part, including its primary school, is in Bedfordshire. Once renowned as a health spa with several convalescent homes built locally, the town was anciently in the parish of Wavendon and known as Hogsty End. A local story endures that a Victorian schoolmaster, unable to attract business to his Hogsty End Academy, was among the first to promote its new name, Woburn Sands.

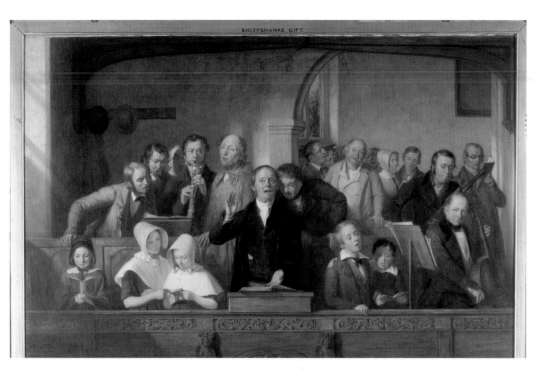

South to Bow Brickhill's Village Choirs — by Webster c. 1847 and in 2008

Perched on the steepest hill in the borough, Bow Brickhill was once part of the Duke of Bedford's estate. Village men cut larch trees for railway sleepers or quarried ironstone from the Sandy Ridge. Women and girls had to work at plaiting straw hats or lacemaking, sustained, no doubt, by tales of elopement and emigration of the local Munday family. Nearby Wavendon Wood incorporates an Iron Age hill fort called Danesborough (now the name of another celebrated local choir).

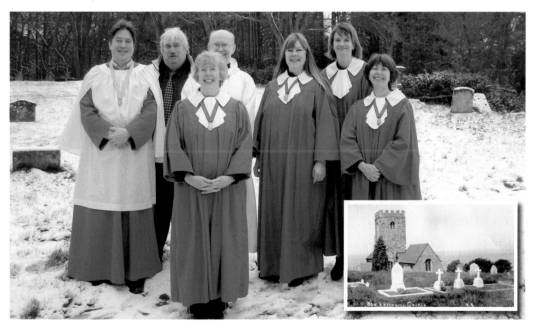

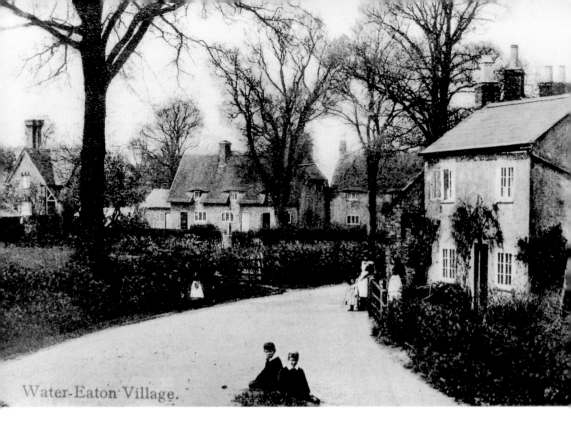

Water-Eaton Village.

Water Eaton — the Borough's Southernmost Community

The borough boundary leaves the Brickhills, including the village of Little Brickhill, high up on Watling Street, for the designated new city area — which begins now at Water Eaton. Once a hamlet in Bletchley parish, Water Eaton is half a mile from Fenny Stratford. Crossed by the Grand Union Canal and River Ouzel flowing into the River Great Ouse, its centre erstwhile defined by Mill Road, Water Eaton still harbours its quiet little backwaters, some of them unchanged through centuries.

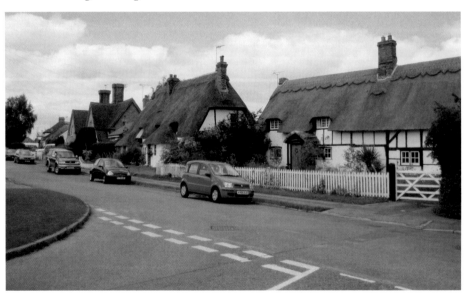

The Southern Bletchley Brickworks Transformed

The brick industry inevitably centred on Bletchley because of its thick seam of brick clay and convenient railway crossroads. The London Brick Company, one of the biggest employers in the 1930s, had 400 men making 700,000 pressed bricks weekly. The company provided a hostel in Drayton Parslow with workers from Poland, the Ukraine, Yugoslavia, Czechoslovakia and Italy, including ex-prisoners of war. By the 1980s, the brickyards were closed and a beautiful nature reserve took their place — The Blue Lagoon.

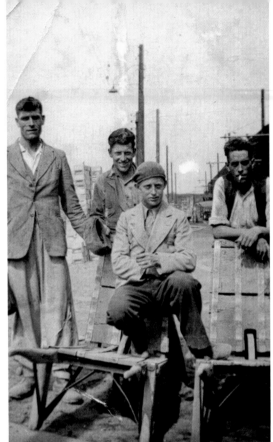

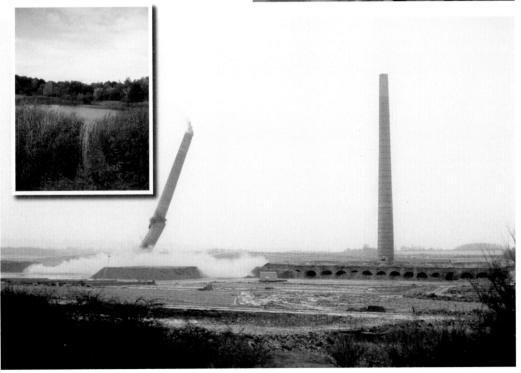

Nearing the Boundary's End — Eastwards to Shenley Brook End

The borough boundary has nearly come full circle. West of Far Bletchley is ancient Tattenhoe which had just twenty residents in 1931. Now it is part of the civil parish of Shenley Brook End whose brook rises near the site of Snelshall Priory at Westcroft, flows through Furzton, becomes the 'tear-drop' balancing lakes in Loughton flowing into the River Great Ouse at New Bradwell. The wall (left above) still displays 'Flowers Ale' of a former pub, now refurbished as a home.

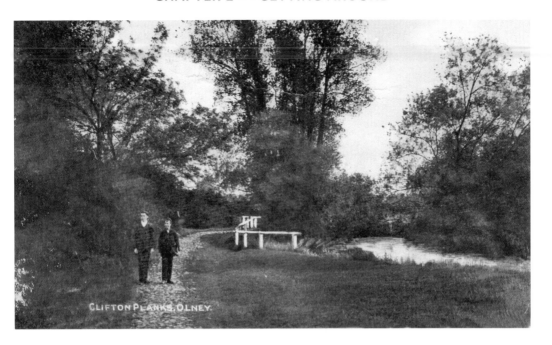

Local walks — as at Olney and Bancroft

Olney's riverside walk at Clifton Planks (top, 1915) connects with nearby Emberton Country Park and 270 kilometres of new city 'Redways' (bottom, 1985). Longer-distance walks like Grafton Way or North Bucks Way begin at Wolverton, Three Shires Way at Tathall End and Swan's Way at Salcey Forest. The city's thirteen miles of the Grand Union Canal paths traverse Fenny Stratford, Simpson, Woughton, the Woolstones, Great Linford and Wolverton with thirty-six canal bridges — increased from the original thirteen because of new city development.

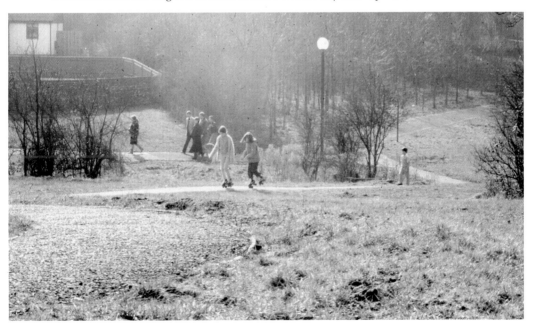

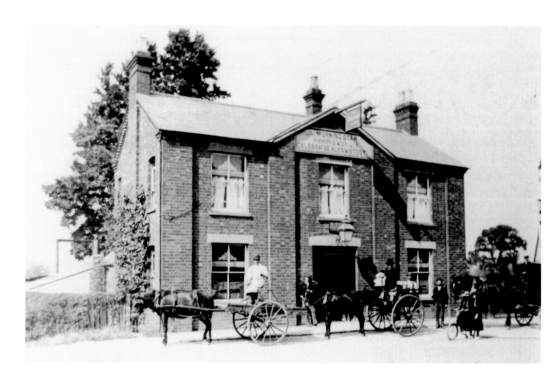

Transport at the Morning Star, New Bradwell

Horse transport was a significant factor in our region's development. From 1785, London stagecoaches exploited the Romans' ancient route to the north — Watling Street — spawning numerous alehouses on or near it. The Morning Star pub (above in 1910) was built c. 1858 on the old turnpike Newport Road primarily to service New Bradwell railway workers and also its own local horse-drawn clientele. The building was destroyed by fire in 1963 and demolished in the 1970s. New city residences replace it.

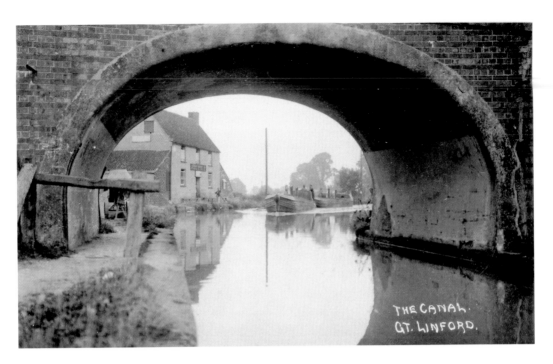

The Canal at Great Linford

The longest, widest canal ever to be built by one company, The Grand Junction (renamed in 1929 as The Grand Union), came here to Great Linford in 1805. By 1817 a branch canal opened up to Newport Pagnell — one and a quarter miles long with seven locks — transporting coal, stone, manure, bricks, timber, malt, oil and salt. In 1866, it was emptied, covered with ballast and taken over by the railway; 110 years later the dismantled railway became part of the city's Redway system.

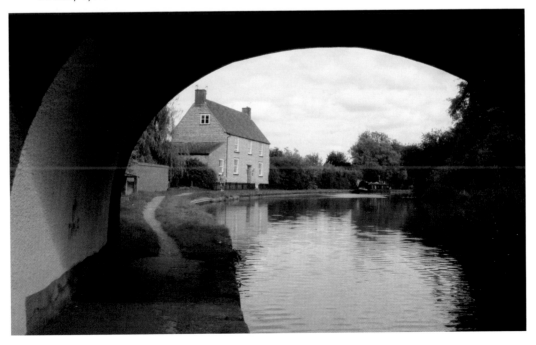

The Canal at Peartree Bridge and Woughton on the Green

Peartree Bridge is now home to the community arts charity InterAction-MK 'bringing arts to life in Milton Keynes'. The bridge crosses the canal (right) to what was once a twenty-acre village green at Woughton on the Green — retained as part of the new city plan. Now the centre of a huge civil parish, Woughton includes such new city communities as Beanhill, Coffee Hall, Netherfield, Peartree Bridge, Tinkers Bridge and Woughton Park.

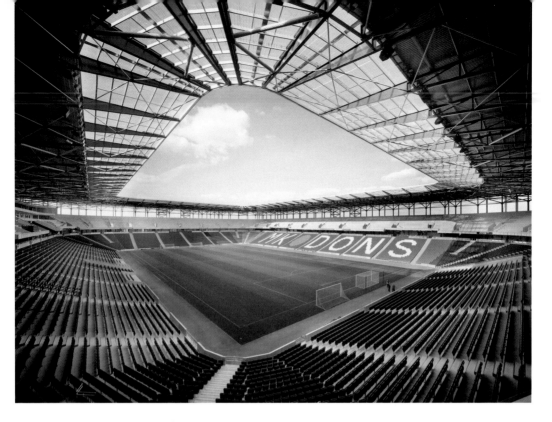

The Transformations of Denbigh

Supplanting canals, the London-Birmingham Railway opened in 1838, but only to Denbigh Hall — stagecoaches took passengers further north. The Denbigh Inn (below right) twice saw its fortunes transformed, from sleepy backwater to bustling terminus and back again when the line extended to Wolverton (immortalised in Living Archive's musical documentary *All Change*). The area's modern metamorphosis is within half a mile of the old bridge with extensive commercial development and the magnificent stadium:mk (above, photograph courtesy of MK Dons Football Club).

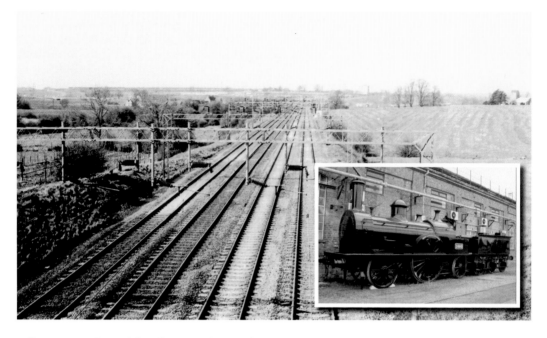

Milton Keynes' Special Railway Heritage

War with America was averted in 1860 when James McConnell's celebrated Bloomer engine from the world-famous Wolverton Works raced to London with the crucial 'Trent Dispatches'. Its scale replica (inset above) was built by modern Railcare apprentices. Also above is the view towards Loughton in 1974. Milton Keynes Central Station — seen below at its opening by Prince Charles in 1985 — is sited near a siding at Loughton. The workmen's train for Wolverton Works would stop there for them every morning and evening.

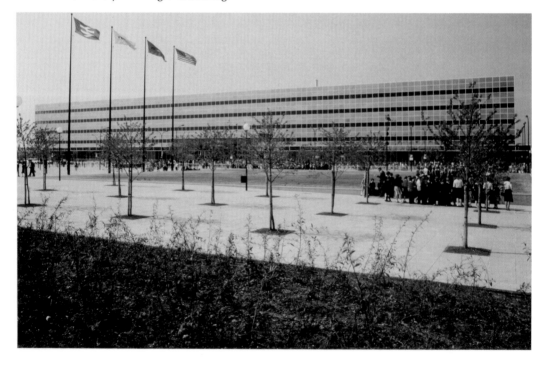

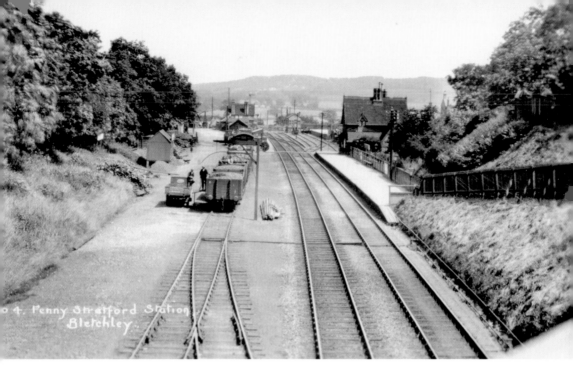

Fenny Stratford Station Looking East (Above) and West (Below)

My grandfather, Henry Sear lived in a railway house by Fenny station. He used to be a Fogman. There was a bell upstairs on the landing. They'd ring it from Fenny signal box if they wanted him out to go fogging. The Fogman would put a detonator on the line to tell the Driver whether the signal was on.

Generations of Ron Sear's family worked for the railways, like thousands of Bletchley and Wolverton families since the 1840s.

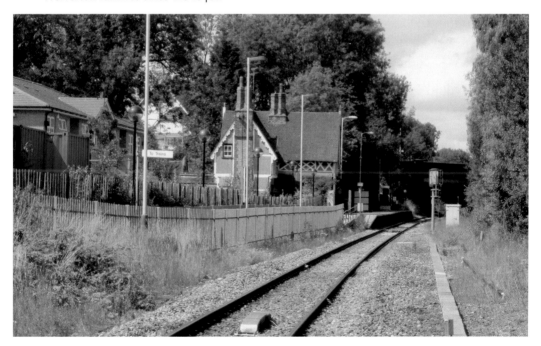

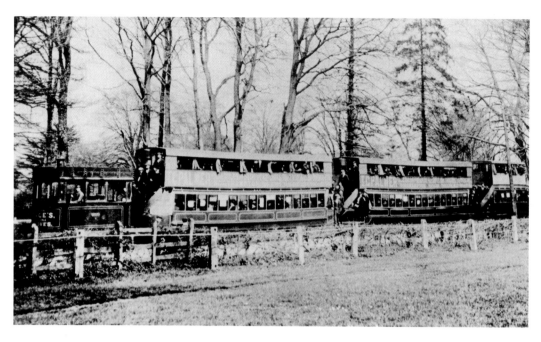

From Victorian Steam Tramway to Modern Public Transport

Specially provided for Wolverton Works' employees was the steam tramway which opened in 1887 and eventually ran between the Barleymow pub in Stony Stratford and Wolverton Station. Its tramcars were the largest in the world, holding 100 passengers apiece. They were pulled along by the *Puffing Billy* steam engine on a narrow gauge railway in the middle of Stratford Road. The last steam tramway to operate in Britain, one of its famous tramcars can be seen at Milton Keynes Museum.

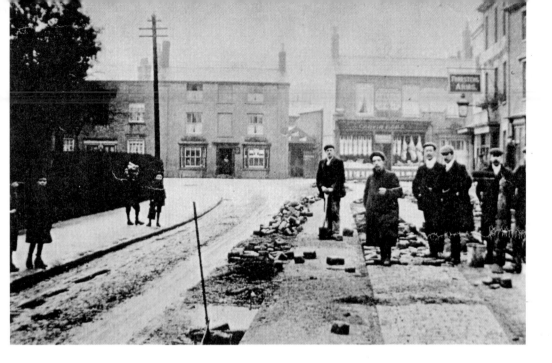

The Steam Tram Rail Site, Stony Stratford

The tram continued successfully for many years but faced financial difficulties mainly because of the increase in buses in the area, and by 1918 it faced closure. It was rescued by the London & North Western Railway, operator of the mainline running through Wolverton and owner of The Works. By 1925 the tram was again losing money. Tram staff joined the general strike in May 1926 and the line closed. Soon after, its rails were removed forever.

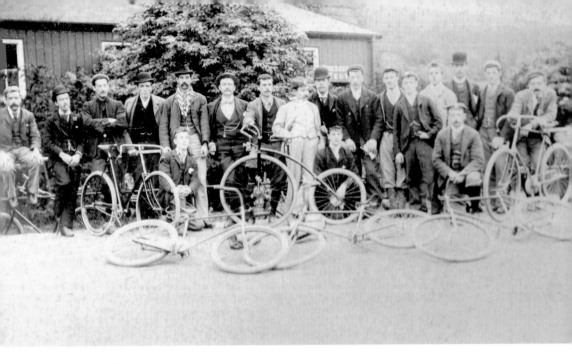

Cycling in Milton Keynes

The Cycling Tourist Club, founded in 1878, spawned local clubs (as above) and since 1977 Milton Keynes has had its own cycling club (MKCTC). The city and borough host two National Cycle Network routes and four Heritage Trails — around new lakes, ancient villages, public art works and along the Grand Union Canal, like at Fenny Stratford (inset) — as well as having hosted national events, from the Milk Race 1978 (below) to the Tour of Britain 2009.

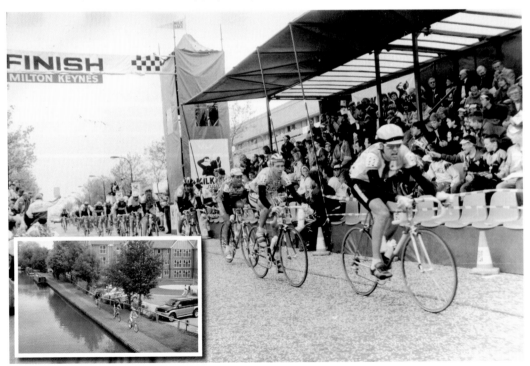

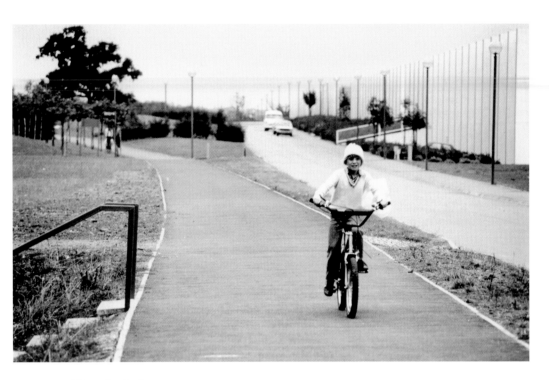

Travelling the Redways

The Redways are the most extensive network of cycle routes and footpaths anywhere in Britain. They run along grid-road corridors, around new city estates (like Netherfield above in 1975) but mostly through 4,000 acres of parkland — twenty per cent of the city's total area — as at Great Linford (below) which is cared for by the Parks Trust charity: 'Milton Keynes is really the city in the country' with many more wildlife species recorded now than when the city area was purely agricultural.

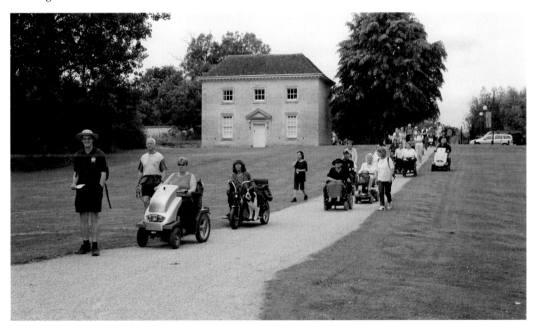

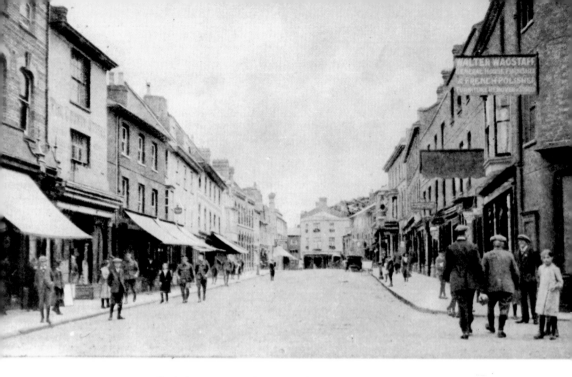

Newport Pagnell High Street Looking North

Newport Pagnell was once one of the largest towns in Buckinghamshire with County Assizes, two hospitals and six fairs. Its two bridges were both built over the Lovat (or Ouzel) in 1810, with the iron Tickford Bridge the only one in Britain still carrying main-road traffic — and the oldest in the world still in constant use. The town was a Roundhead garrison in the Civil War 350 years ago, and it was home to Aston Martin for over 50 years.

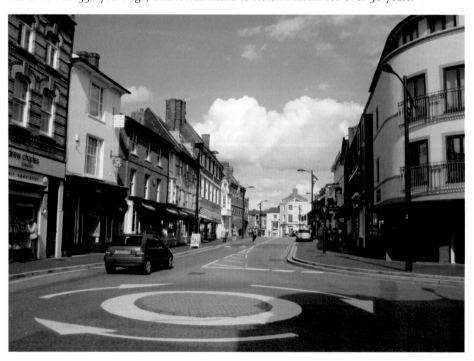

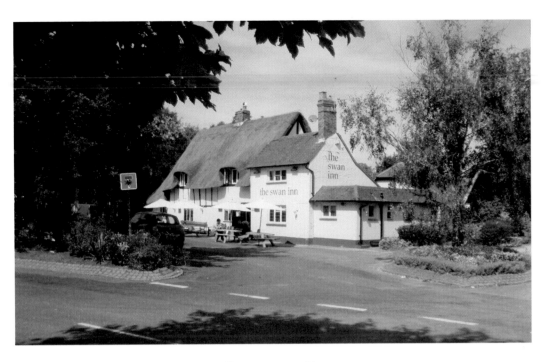

Stopping off at The Swan Inn, Milton Keynes Village

The village that gave its name to the new city of Milton Keynes was originally known as 'Middleton', later evolving to 'Milton'. After the 1066 Norman invasion, the Cahaines family held the manor for 100 years along with others around the country (Ashton Keynes, Somerford Keynes and Horsted Keynes). The village became known as Middleton de Keynes, eventually shortening to Milton Keynes. These early motorcyclists would have found a strong tradition of refreshment in the 700-year-old Swan Inn.

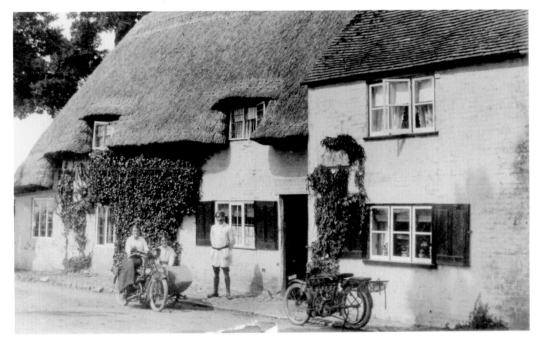

Navigating Through Simpson Village

Once, it was difficult to navigate through Simpson village: in winter, it would be cut off by a flooded ford 200 metres wide and 1 metre deep, causing one traveller to comment that it was *'in appearance one of the most wretched of many miserable villages in the county'* (J. J. Sheahan, 1862). Not so now! One of the original thirteen ancient villages to be part of the designated city area, Simpson hosts Tudor cottages enjoying protection from the new city plan.

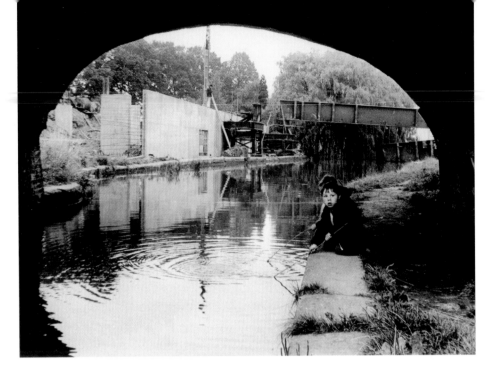

Canal-side Recreation at Tinkers Bridge and Bowlers Bridge, Simpson

Though the canal, invisible from nearby, makes little impact on the larger landscape, it is an asset to be exploited locally to the full: for boating, fishing, canal-side walks and above all as scenery.

'The Plan for Milton Keynes' produced by the Milton Keynes Development Corporation (1967-1992) allowed for the development not only of key grid road access across the city (as above with the 1972 construction of H9 Groveway) but of key public access to recreational facilities.

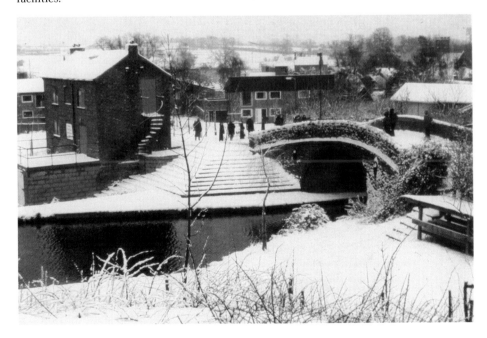

Boating on Willen Lake

The Masterplan stated, '*Balancing reservoirs which are required along the River Ouzel for the control of flooding can be deepened to form very attractive lakes for boating and fishing.*' An uncelebrated success of the city's development has been the near-elimination of ruinous floods that plagued the designated area for centuries. Here, the new city lake at Willen demonstrates how a mere thirty-year span of its existence has created new activities for its citizens.

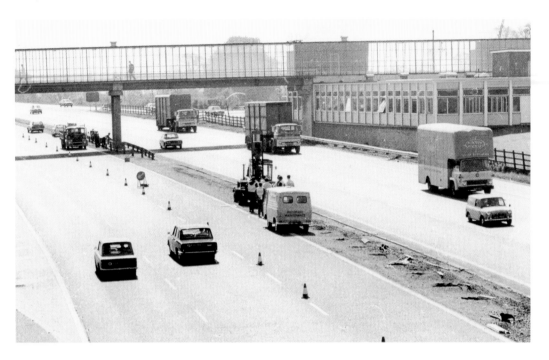

M1 Service Station at Newport Pagnell

The nation's first north-south motorway slices the Milton Keynes Borough in two, with the one of its earliest service stations (1960) halfway along the section. Before the main services buildings opened there had been only emergency facilities for toilets, fuel and breakdowns. But the new services were not without criticism: the fuel on offer sparked outrage in Parliament because of their dubious sources and the architecture was highly censured by arts, landscape and architects' bodies alike.

At Little Brickhill and the View Across the Designated City Area

Little Brickhill is in the borough's south-eastern corner. Once on the major London-Chester road, it was a stagecoach stop with stables, coach sheds and a hotel. Now, its busy travel-servicing days over, it is largely unchanged, its Church Farm peacefully overlooking the new city. Below, the dramatic increase of green city landscaping can be seen in the middle distance, contrasting with the beige still-ploughed fields of 'undeveloped' land in front. The city centre's 'hub' is top left, the Snowdome top centre.

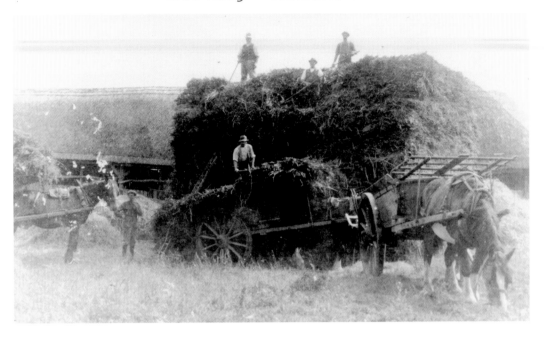

Milton Keynes — from Agriculture to Construction

Agricultural workers toil in the Milton Keynes of 1900, the ancient village which gave its name to, and is still a distinct community within, the new city and borough of Milton Keynes. Now, construction workers, such as those from Alps Scaffolding Services, work in Central Milton Keynes (photograph by Cheryl Butler). Left to right: Ross Kirkby, Gary Samson, Darren Wheatley and Phil Pateman featured in 'A Day in the Life of CMK' on 3 July 2009 (see http://en-gb.facebook.com/people/Living-Archive).

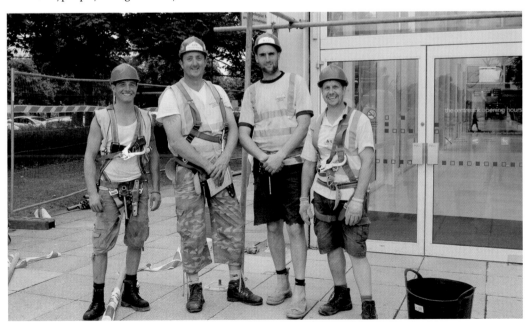

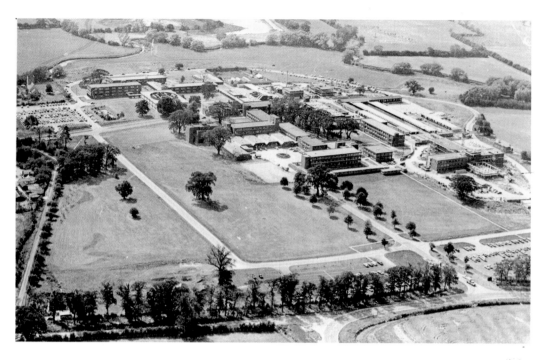

Walton — Home to the Open University Since 1969

Symbolising the transition from an agricultural community to an academic one, the farm (below) which now hosts Hoechst is on the Walton Hall estate whose manor house is base to the Open University (above, 1971) — the nation's largest, and the world's first, for long-distance learning. Celebrating forty years of 'how we change lives, harness technology, and deliver scale and quality', the university's presence in Milton Keynes has helped 'establish and enhance the city in national and international perceptions'.

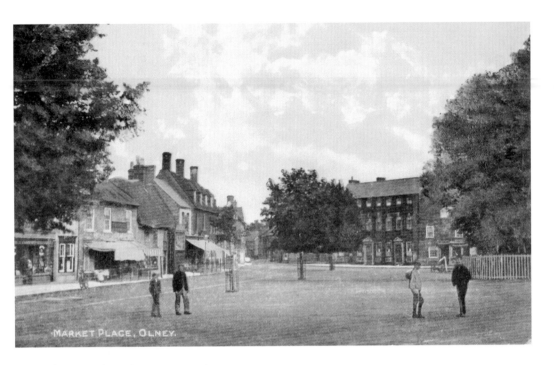

MARKET PLACE, OLNEY.

Olney Market Place, 1907 and 2009

Once made prosperous through its tannery and associated shoe trade, and a pillow-lace industry dating from the sixteenth century, Olney sustains its commercial and agricultural traditions with an annual cherry fair, a weekly market, monthly farmer's markets and — more recently added — its 'Dickens of a Christmas' craft fair. The mile-long High Street also hosts art galleries, jewellers, antique shops, rug and furniture makers, interior designers and fashion boutiques with numerous restaurants, pubs, cafés and takeaways.

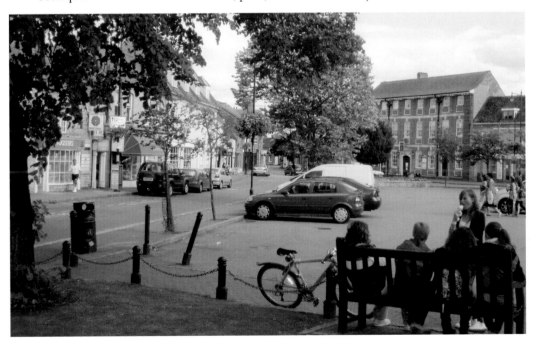

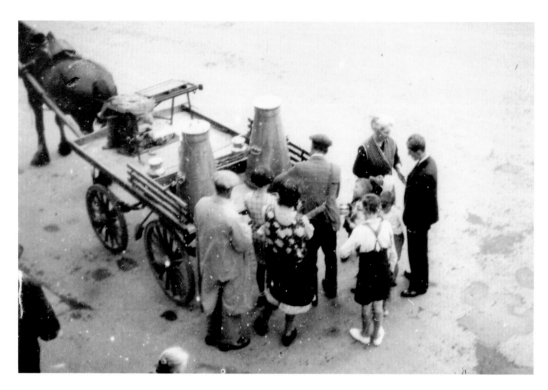

From the Street Trader to the Food Centre

Mr Lines and Mr Dolling came with their milk floats from Shenley each day. They had churns with measures hanging in them. People went out with jugs to get them filled. There was often a nice pile of horse manure... I was dispatched by mother, with bucket and small shovel, to collect this, for her rose trees...

Audrey Lambert's Stony Stratford reminiscence could fit this Wolverton milk trader — contrasting with city centre shopping whose Food Centre was opened by Princess Anne in 1988 (inset).

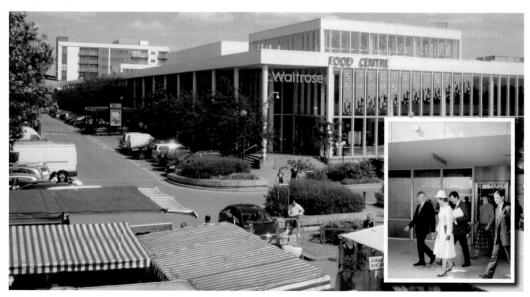

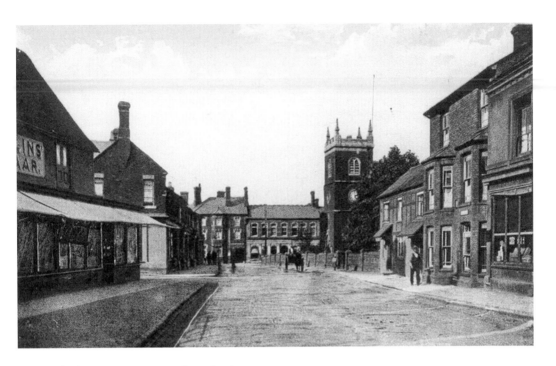

Aylesbury Street, Fenny Stratford

Bob O'Dell remembers Fenny's busy shopping area:

The Post Office in Aylesbury Street was run by Miss Fortescue. The businesses were all in a line —Fortesques Motors, Jack Cherry, the Garage, Papworth's Fruit and Veg... Mr Golding was next to Spurgeons, then Emmerton the jeweller, then the horsy place where you'd take your bets, Adam's, Godden's, Grace's, Davy the Tailor, then the pub.

St Martin's church extension (below right) was completed in 1907.

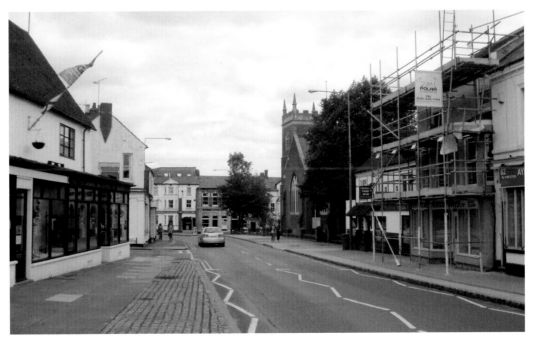

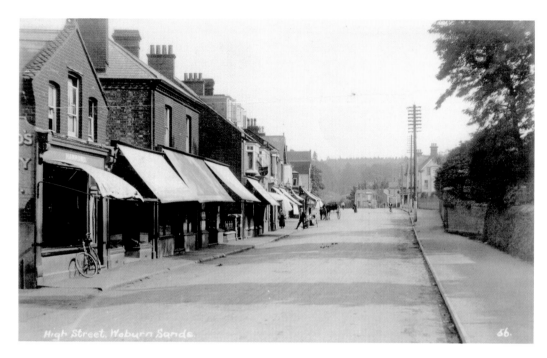

High Street, Woburn Sands

'*The parish is particularly salubrious,*' says Kelly's Directory of Woburn Sands in 1933, '*being situated on the lower greensand formation, which here is a reddish-brown sand, and partly covered by pine woods.*' Among the traders serving its then 1,800 residents were Mr Payne the Blacksmith; Messrs Rice, Pike and Harrison competing as 'Motor Engineers'; Mr Down, offering his 'Wheat Dressing'; and Mrs Dorey with her 'Fancy Repository'.

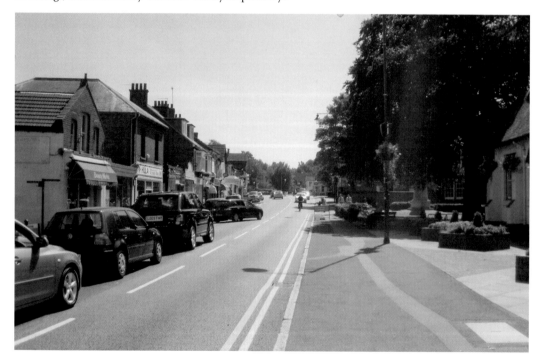

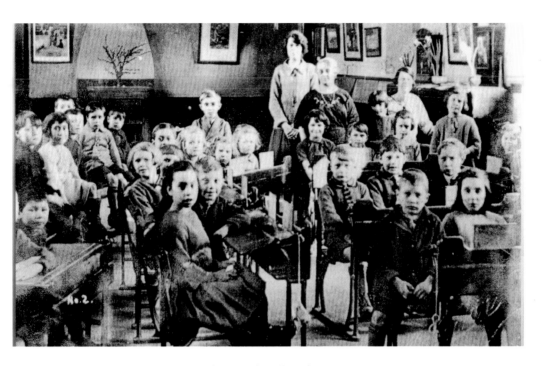

Working with Children at Hanslope and Oldbrook

Hanslope teachers have worked on the same school site since 1873 when the Board School opened to provide basic education for children of local farm-workers and lace-makers. The old school, one of two in the village, was replaced in the late 1960s and extended again a decade later to meet the demands of a rising incoming population. Oldbrook Centre's Mums and Toddlers (below) is one of many city groups which have evolved for much younger children — often supporting working parents.

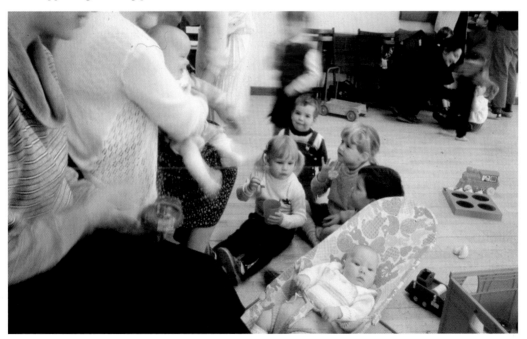

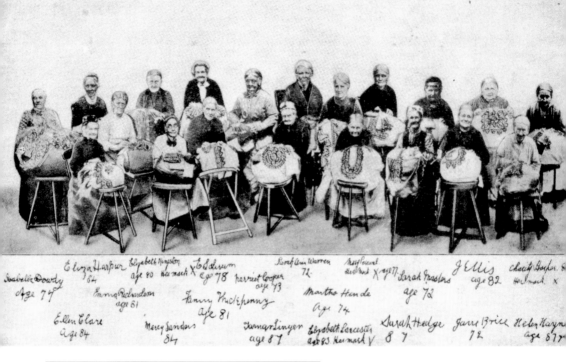

Isabella Dowdy Age 74 · Eliza Harper 84 · Elizabeth Kingston age 90 Her mark X · E S Clissam age 78 · Emma Richardson age 81 · harriet Cooper age 73 · Fanny Muckepenny age 81 · Sarah Ann Warren 72 · Mary Percival Her Mark X age 77 · Martha Hinde age 74 · Sarah Masters age 72 · J Ellis age 82 · Charity Harper 8 Her mark X · Ellen Clare age 84 · Mercy Sanders 84 · Emma Linger age 87 · Elizabeth Larcaster age 83 Her mark V · Sarah Hedge 87 · Jane Brice 72 · Helen Harm age 87 y

The Olney Lace Industry

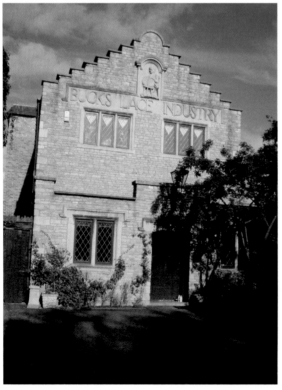

'They sit and worke all along the streete as thick as can be,' wrote Celia Fiennes in 1700 of lace-makers, during her horse ride through the borough area. The industry developed when Flemish Protestants brought lace making to England during the 1560s. William Cowper, Olney's 'lace-maker's poet', wrote in 1780, 'I am an eyewitness of their poverty... hundreds of this little town are upon the point of starving and the most unremitting industry is but barely sufficient to keep them from it.'

Left, the Bucks Lace Industry building in Olney High Street, 2009.

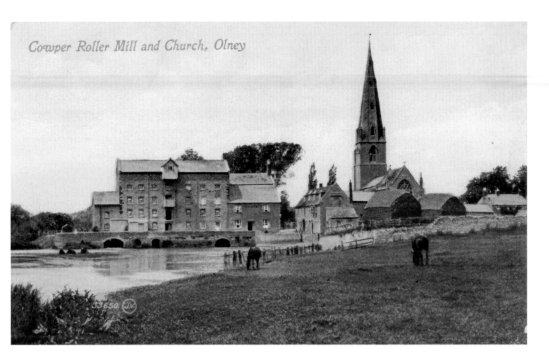

Cowper Roller Mill and Church, Olney

The Mill Buildings at Olney

Oliver Ratcliffe wrote in 1907 that Messrs A. Gudgin and Co., flour and corn merchants, ran the oldest recorded business in Olney. The 1088 Domesday Book reported that the Mill's annual yield was '*40 shillings and 200 ells... It must have been even more important than now*,' said Ratcliffe. Its five-storey building — now no more — was then 'entirely filled with machinery' including two waterwheels and a 45hp 'suction gas-engine' by Grice Engineers of Birmingham, 'powerful enough to work the whole mill'.

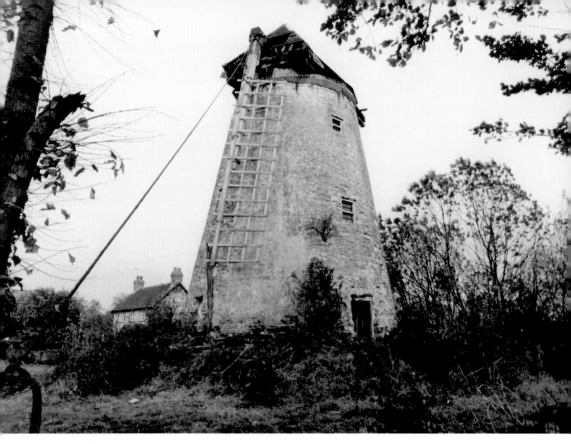

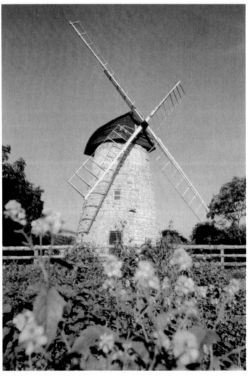

The Bradwell Windmill

The Bradwell Windmill was originally
built in 1805 on an acre of land purchased
by Samuel Holman, costing around £500.
Before it was operational, people from
the area would rely on water mills on the
River Great Ouse or Bradwell Brook. The
windmill ceased working in 1876 when
the railway company bought adjacent land
for the development of the Wolverton to
Newport Pagnell line. It was bought by
Milton Keynes Development Corporation
in 1969, which undertook considerable
restoration work.

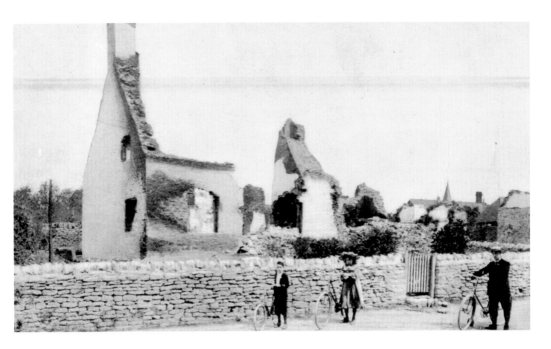

The Great Fires of Milton Keynes

Our region's thatched cottages have provided much work for local fire brigades. The gaps in Ravenstone, Loughton, and Milton Keynes villages — or their newer buildings — indicate where homes once burnt down. Castlethorpe's 'desolating conflagration' reported by the *Bucks Standard* in 1905 had *'burning thatch sent flying by the gusty wind... Thirteen cottages were blazing fiercely,'* with thirty-six people *'left with nothing with which to commence a new home'*. The 1971 fire in Milton Keynes Village (below) continued the tradition for firemen.

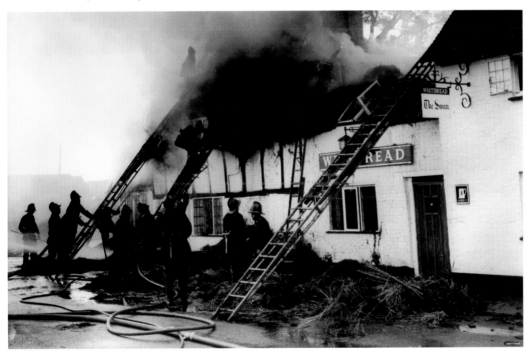

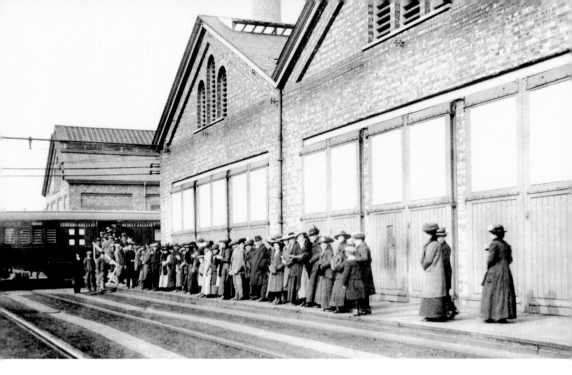

The Ambulance Train, Made at Wolverton Works, 1916

Wolverton's Railway Works employed 5,000 men at its peak (1906). People queued to see one remarkable product, immortalised in song by J. Cunningham – *The Ambulance Train*. First World War casualties were treated in 368 converted coaches. Each had a pharmacy car and treatment rooms with cars for medical officers, nurses, orderlies, kitchens, mess rooms and stores. Ten wards including one for infectious disease, had thirty-six cots each for 'lying-down cases', were steam-heated, and painted in khaki with a red cross.

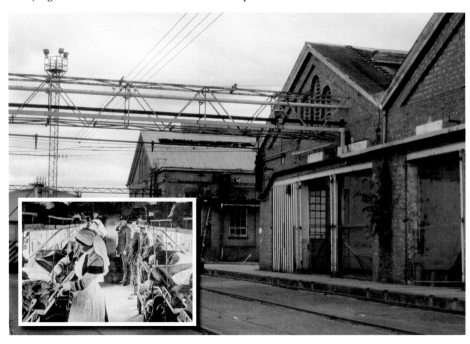

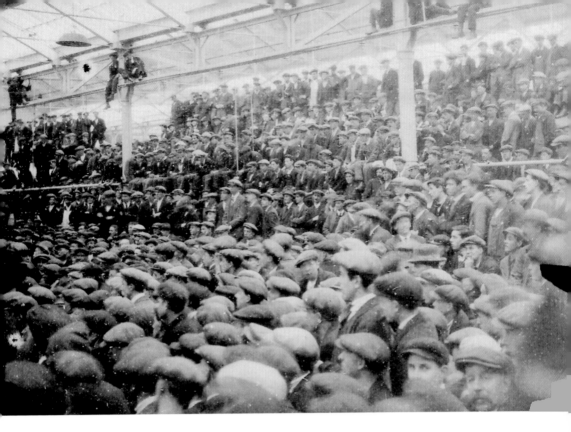

Inside Wolverton Works, 1925 and 2009

'Things weren't right in the Works,' recalled Bill Elliott about a troublesome Foreman. *'So we walked out — a stay-in strike! The whole Works was "out" for nearly a week. The General Strike followed soon after...'* Wolverton had built 166 locomotives between 1848 and 1863, including McConnell's famous Bloomer engine. Then it became the country's largest carriage works — including the Royal Train. Railcare has modernised part of the site to create an up-to-date maintenance and repair facility.

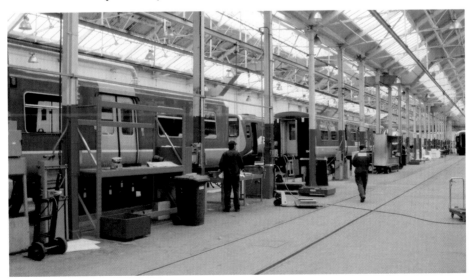

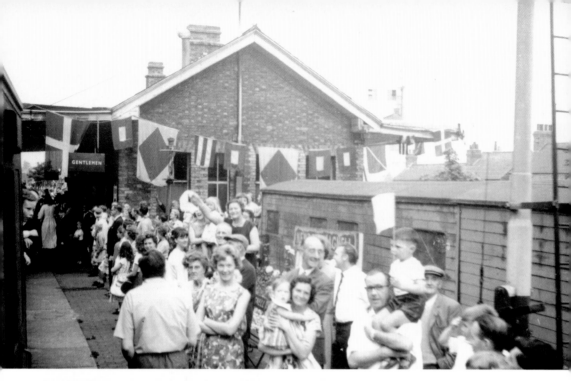

From 'Nobby Newport' to Railway Walk

'320 workmen travel on the "early morning special" and 93 schoolchildren and Works office staff catch the 8.15. And there is the corresponding rush in the evening,' reported the *Wolverton Express* in 1961. There were up to fifteen trains a day each way taking four minutes to get from Bradwell to Wolverton, and ten minutes to Newport. But Beeching's cuts ensured closure for the Nobby Newport on its four-mile line after ninety-seven years' service. One signal survives on Railway Walk (left).

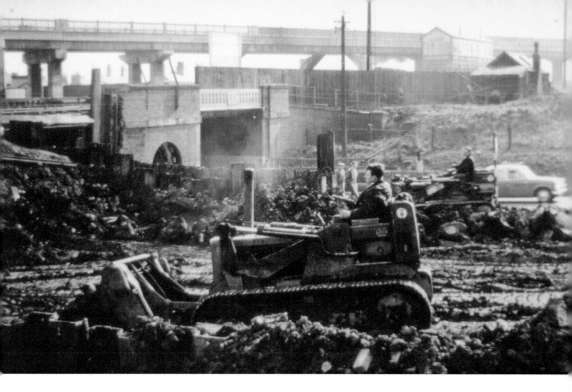

Bletchley Road Construction

New construction has predominated in the Milton Keynes area since the world's first large planned new town began at Wolverton in 1838. *Bletchley Gazette's* campaign to make the town 'Bigger, Brighter, Better' culminated in substantial development in the 1950s and '60s, even before the construction of Milton Keynes was considered. Bletchley's five-year plan to expand the town's population by 5,000, building 1,500 houses costing £3.5 million would later be dwarfed by the sheer scale of new city facilities.

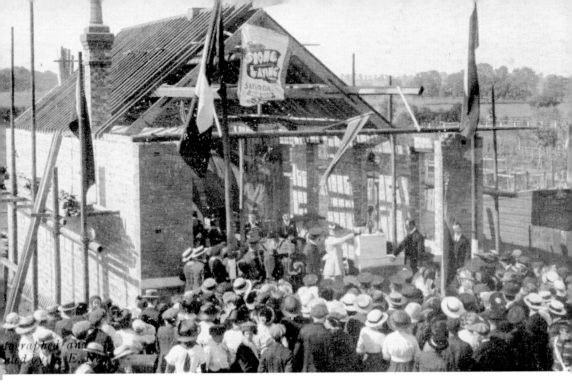

New Construction for 'Stantonbury', 1915 and 1973

Stantonbury was originally an ancient parish whose church ruins of St Peter's are close to the River Great Ouse on the northernmost edge of the borough. Renamed New Bradwell when customised homes for railway workers were extended in the 1850s, it was still 'Stantonbury' to locals well into the next century. In the 1970s, it hosted the city's first purpose-built community comprehensive school; Stantonbury Campus, including the leisure centre, is now a specialist arts college for 2,600 students aged 11-18.

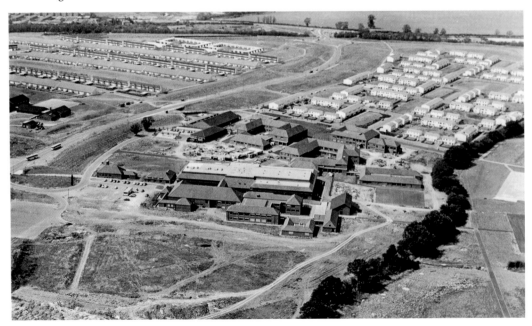

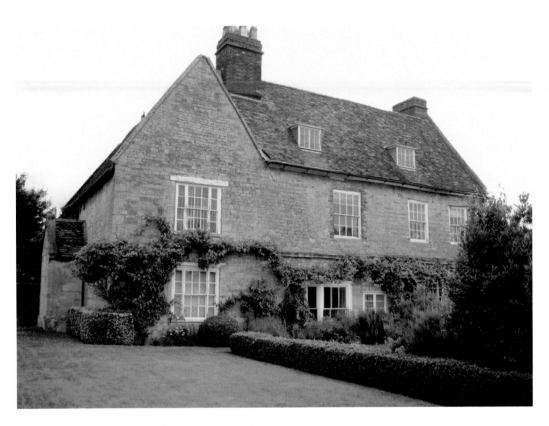

Bradwell Abbey Farmhouse, 2008 and 1971

This site of a medieval priory is now home to Milton Keynes City Discovery Centre which provides 'educational programmes and activities to support all levels of learning in urban studies and the sustainable city'. Below, as a working farm with its fourteenth-century chapel used as a 'lumber store' it was said to be visited by 'a chariot whose occupant carries her head under her arm' (*LMS Railway Route Book 1947*); now, it is eponymous with a city industrial estate.

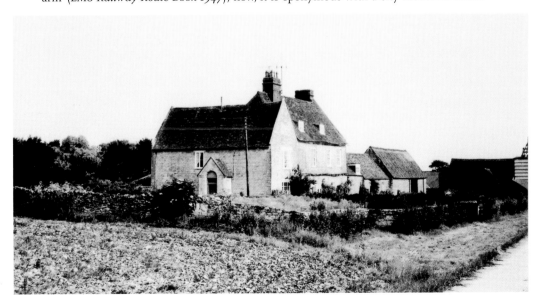

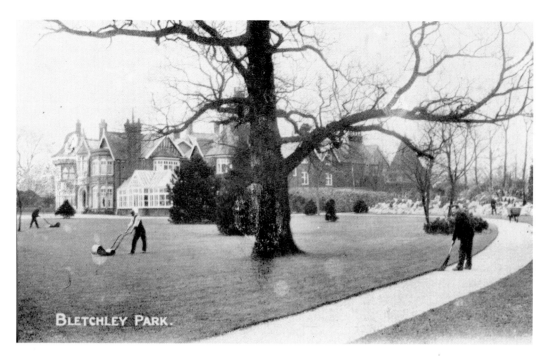

Bletchley Park Mansion

By 1920, Sir Herbert and Fanny Leon employed forty gardeners maintaining forty-four acres at their Bletchley Park mansion and would replace their glass conservatory with a dining-room extension (below). But their home — now cared for by the Bletchley Park Trust — became legendary as the modern computer's birthplace. After Lady Leon's death, the mansion became the British Government's top-secret Code and Cypher School during the Second World War — 'Station X' — where nearly 10,000 people worked and 'never blabbed about it'!

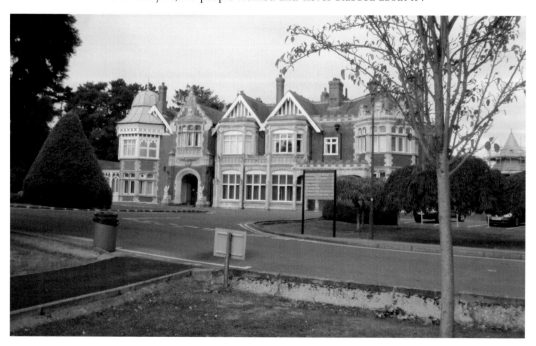

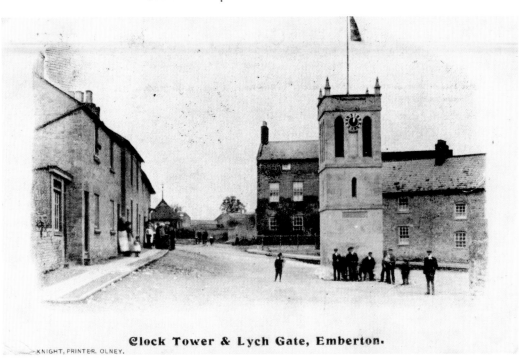

Clock Tower & Lych Gate, Emberton.

KNIGHT, PRINTER, OLNEY.

Clock Towers

The families of Emberton can stand
alongside England's best —
Edmunds, Lovell, Lett and Brown,
Mynard, Howson, Cave and West.
Two wars dealt an ugly hand to every
village in the land.
The local lads that heard the call, the
Clock-tower lists them, one and all.
'Returning some their story tell, the
trench, the charge, the comrade's fall'
And those that fell are named in gold
upon the stone memorial.

(From the song Emberton
by Kevin Adams, 1994)

The city's newer clock tower in Neath Hill's local centre has a less melancholy function.

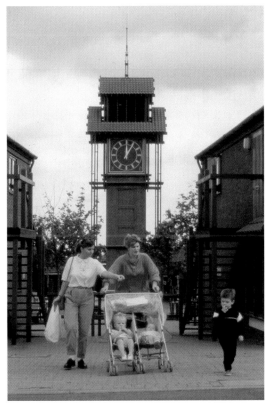

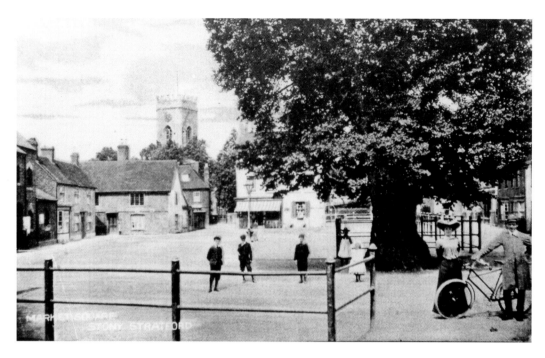

The Tree in Market Square, Stony Stratford

In 1777, John Wesley made his reputed fifth visit to Stony Stratford to preach at the town's Market Square elm tree. Local Methodist church members still hold an annual memorial service at the tree. Around three hundred years old, with a girth of seven and a half metres (twenty-five feet), the tree suffered from Dutch elm disease, vandalism and arson attacks. It was reduced to a hollow but has now been replaced with an oak.

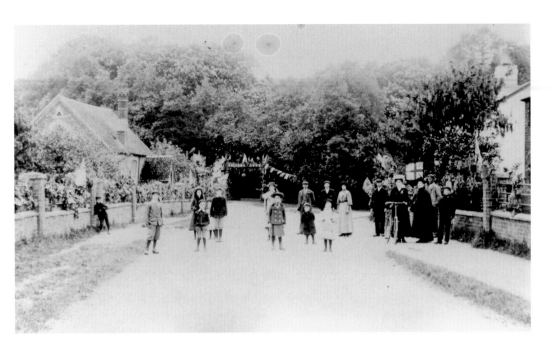

Community Meeting Places

A prehistoric mammoth, Iron Age millers, Roman settlers, a Saxon hairdresser — all left evidence that Milton Keynes Village was a significant meeting point even before its mention in the Norman Domesday Book of 1086. Above is where children of the village would congregate, especially if a photographer was around. In the new city, planned and customised meeting places for residents and their families were created for each new estate, as below at Heelands.

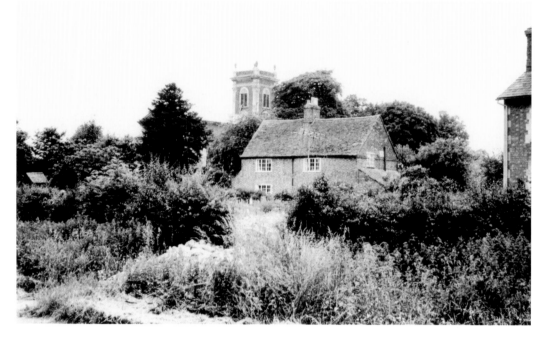

Congregations at Willen

In 1680, Sir Robert Hooke, curator of the Royal Society and leading scientist of his day, designed Willen's Church of St Mary Magdalene. Today, its tower overlooks modern Willen Lake — one of the eleven balancing lakes around the new city designed by ingenious water engineers to solve the perennial problem of flooding from the River Ouzel. Now, new congregations gather too — mallards, coots, Canada geese, wigeons, tufted ducks, pochards, teals, mute swans, shovelers, golden eyes, and thousands of gulls.

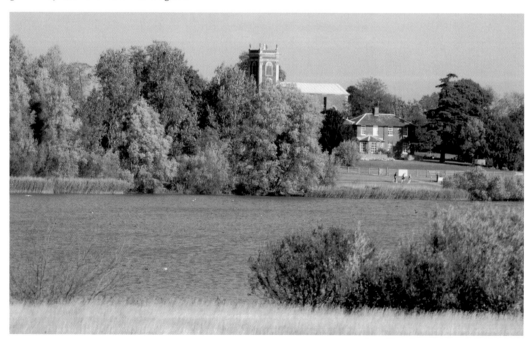

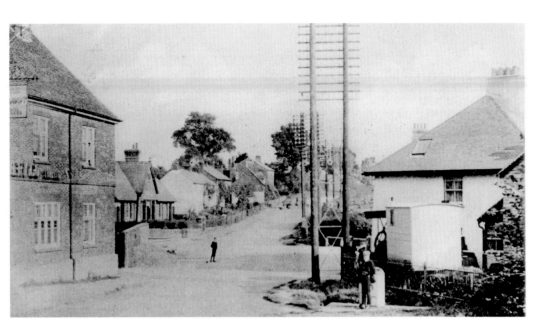

The Pub at London Road, Loughton

Loughton's London Road, a national route for 2,000 years, was the Roman route to Chester, an eighteenth-century turnpike road, and the twentieth century national A5 route. So throughout its 200 years, the Talbot (above) evolved from being a stagecoach stop, later advertising 'Garage, Petrole and Stabling' (1910), to offering quick-service 'refreshment rooms' (1950) popular with coaches. By 1979 the Talbot was a re-born new city village pub. Under new management, it has been renamed the Oak Tree (below).

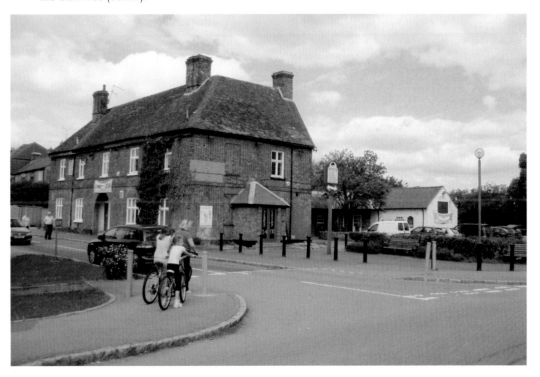

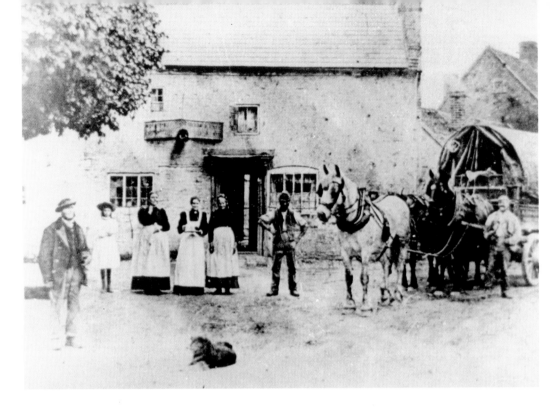

The Barge Inn, Woolstone

Great Woolstone and Little Woolstone are two historic villages in modern Milton Keynes, now forming the heart of the new district of Woolstone. In the Domesday Book of 1086 the area was recorded as *Wolsiestone*. Today, Little Woolstone is the larger of the two, having benefited from the building of the canal 200 years ago with its village pub, the Barge Inn, originally opened to meet the needs of boatmen and their horses.

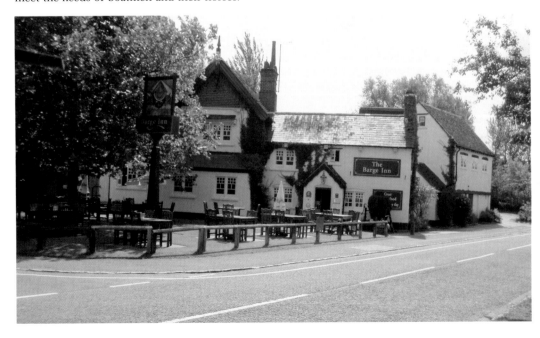

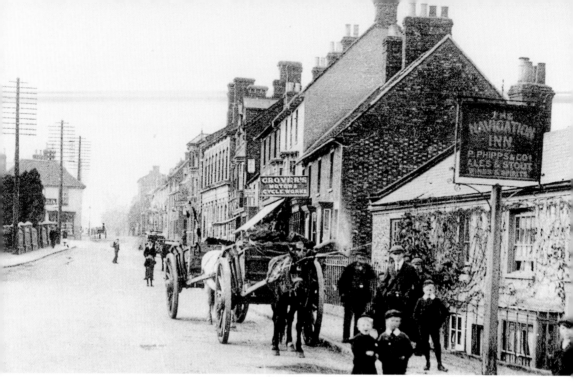

Fenny Stratford's Inn at the Bridge

In 1819 Fenny Stratford was described as '*a small decayed market town, built in the shape of a cross*'. By the 1930s, its population was four times bigger than Bletchley, enjoying many Victorian developments. One is shown here: the Bridge Inn (below), erstwhile the Bridge Hotel in the early twentieth century, is a replacement for an older canal-side inn — the Navigation (above). Although the building next to it was also replaced, those further up the High Street survive.

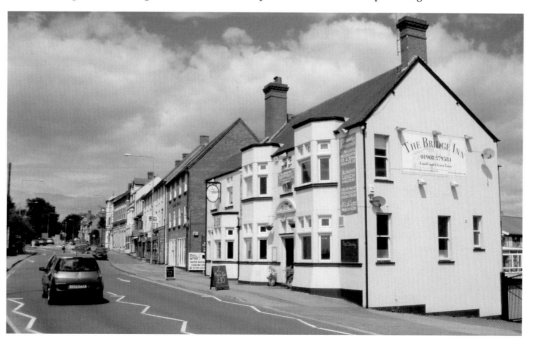

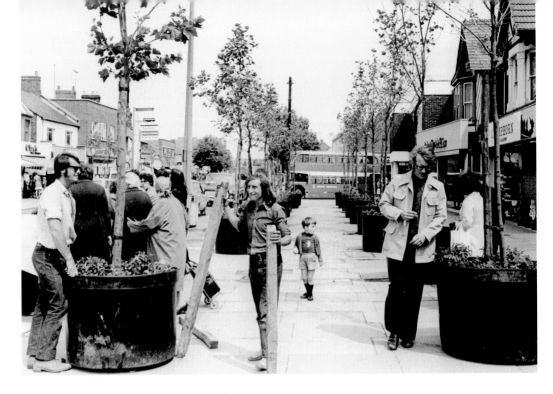

Bletchley Queensway, 1970s and 2009

We'd been trying, on the Council, to get rid of this silly 'Bletchley Road, Bletchley' idea. All the traders said, 'No — cost us money to reprint our noteheads...' and so on. Then the Queen came!

Ron Staniford recalled how the town's main road was renamed Queensway in 1966. In the 1970s, Bletchley helped provide early vital services for the new city including a leisure centre, golf course, new shopping centre and a supermarket. Now further regeneration is at hand.

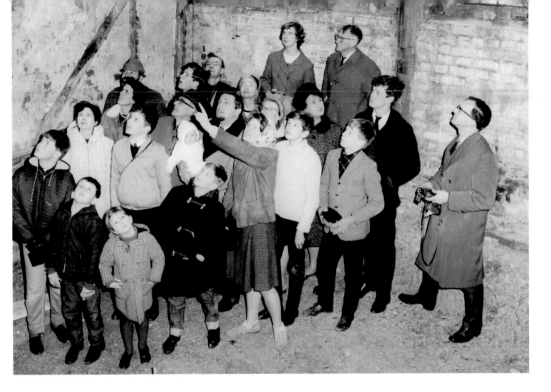

Rectory Cottages, Church Green Road, Bletchley

'*Except for the nearby parish church, Rectory Cottages seems to be the oldest building in Bletchley. It was built about 1475 and has been lived in ever since.*' Sheer doggedness by dedicated enthusiasts ensured the survival of this remarkable building, as recorded on their website. With timber frames, hammer-beam trusses and moulded beams, Rectory Cottages underwent extensive restoration between 1968-1974 and is now used for community gatherings around 400 times a year.

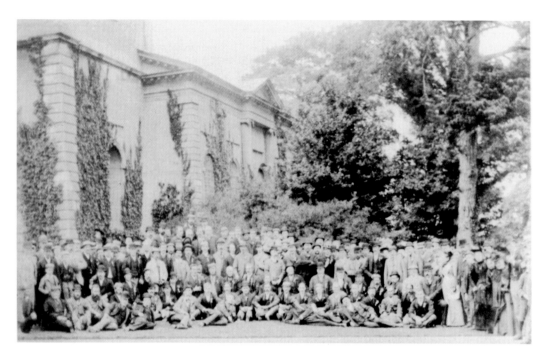

Gayhurst House

Once the seat of Sir Walter Carlile OBE (1862-1949), Gayhurst House played host to the Primrose League (above), a 'quasi-masonic' society formed in 1883 to promote Conservative Party principles and imperialism. By 1910 it had attracted some two million members but was disbanded by 2004. Gayhurst House — reportedly owned by Sir Francis Drake, home to Gunpowder Plotter Sir Everard Digby and a Second World War code-breaking outstation — was converted to private apartments in the 1970s.

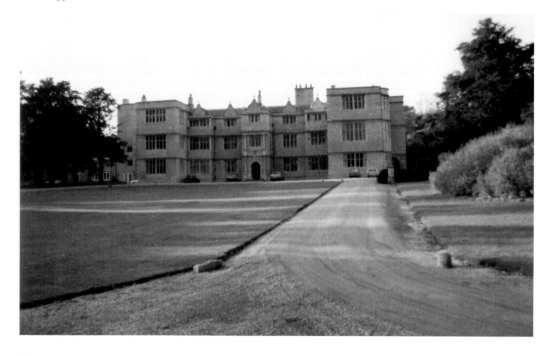

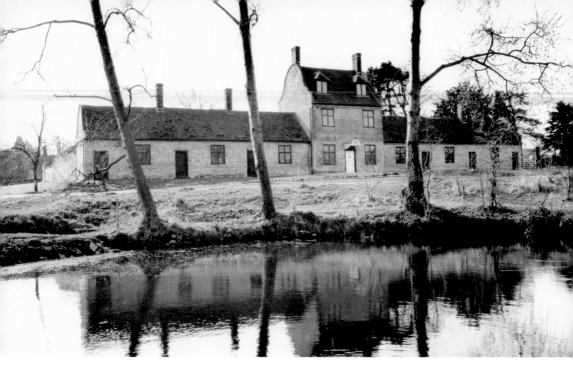

Great Linford Manor Grounds

Great Linford currently attracts crowds for its popular annual Waterside Festival (below — photograph by Jamie Slee) but it has long been a key meeting point. Its Manor House built by Sir William Pritchard (1680) has evolved into a recording studio and the centre of large-scale community events. The original schoolroom, schoolmaster's house and six almshouses (above) which remained in use until the 1960s were converted 1975-82 to a community arts and crafts centre, one of the three city Artworks MK sites.

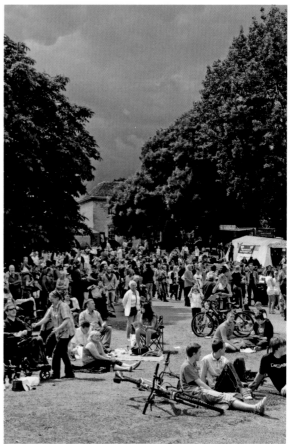

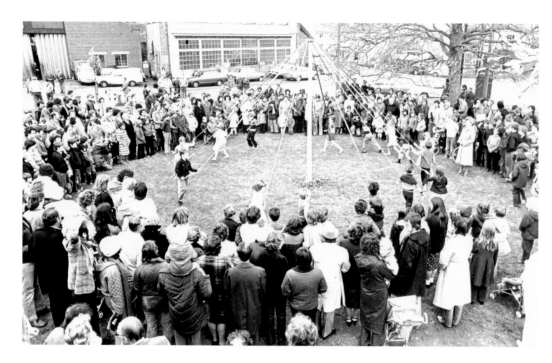

Sherington May Day Celebrations

Just north-west of Newport Pagnell, the village of Sherington traditionally held several festivals and fairs throughout the year, including Mayday, Harvest Festival, local fairs, the Village Feast and even the Gunpowder Plot Holiday. The school would close for a half-day or even longer. Although most are no longer celebrated as holidays, Mayday is still marked by children from the school dancing round the Maypole (as above in the 1960s and Kay Turrell's 2007 photograph) — despite being rained on in 2009!

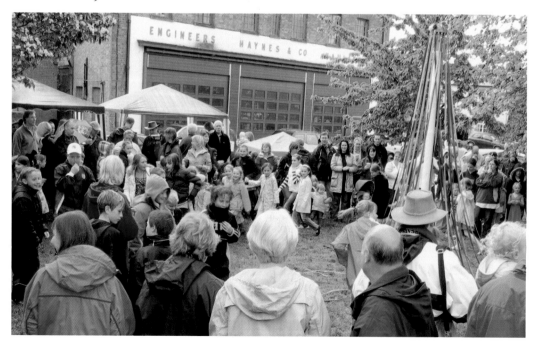

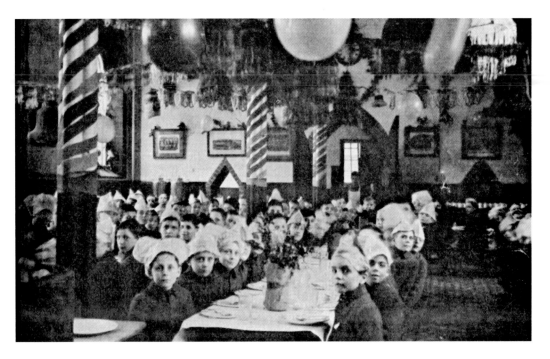

Children's Christmas Parties

J. W. C. Fegan bought St Paul's School in Stony Stratford in 1900. A wealthy and religious man, he had dedicated his life to helping homeless boys in London and wanted a home for his 'bold, pert and dirty London sparrows'. It became Fegan's Home for Orphaned Boys — now it is a restaurant. From 1900 to 1961 4,000 boys were given shelter, education and a future. But the hard discipline imposed upon them perhaps shows in the faces above, contrasting with the more relaxed children of Wolverton Workers in the 1980s.

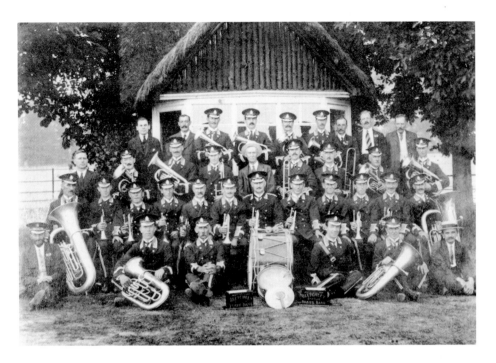

Brass Bands

The Bletchley Show became nationally famous. There were sheepdog trials, horse-jumping, cycling, tennis tournaments, flower-show, fun-fair, athletics, tugs-of-war, floodlit dancing, a gigantic, spectacular fireworks display, and a brass band playing throughout. (Ivy Fisher)

The tradition of old-established bands such as Bletchley (above *c.* 1910) Woburn Sands (1867), Bradwell (1901), Wolverton (1908) and Bletchley Boys' Brigade (1928) was re-energised when new city bands emerged, such as Stantonbury Brass, Broseley Band and the newest, Milton Keynes Brass. Below, Willen Lake audiences enjoy their music.

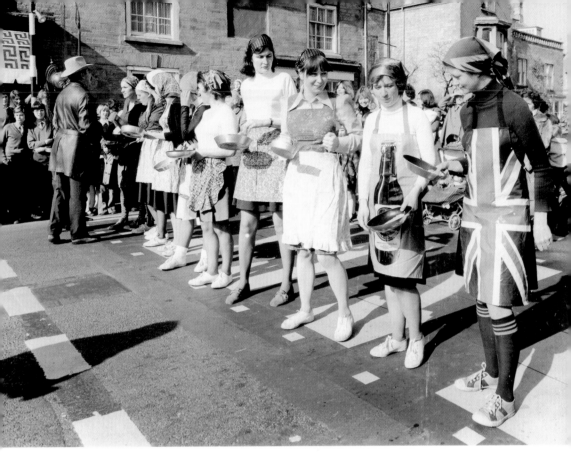

Racing Women

The 500-year-old Olney Pancake Race is run every Shrove Tuesday from the Market Place to the church. Participants, 'housewives or young ladies of the town', must wear 'the traditional housewives' costume' and carry a frying pan containing a pancake. The winner, on crossing the line, must toss her pancake and be greeted by the verger with the traditional kiss of peace. Now, in addition, thousands of Milton Keynes women raise money for Cancer Research in the annual 'Race for Life'.

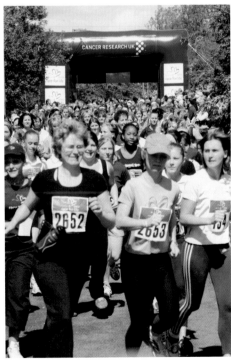

The National Bowl's Site — and its Promotion

The Bowl was Fletton's Brick Pit, 120ft deep, ideal for utilising spoil from housing areas being developed — Netherfield, Coffee Hall, Bean Hill. We built the amphitheatre shape... First was 'Soul in the Bowl' (1979), then Police, notorious because of the mudslides... 1983 was the big one, David Bowie for three days. The sun blazed down with people everywhere, looking like a swarm of bees.

(Brian Salter)

MK Bowl...host to the world's leading stars including Michael Jackson... attracts international cycling, show-jumping, car-rallies and trade launches.

(Promotional postcard)

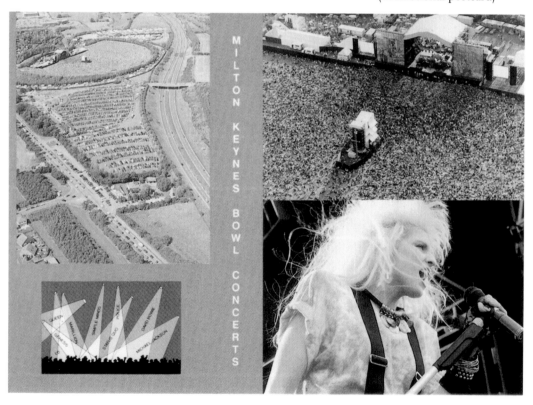

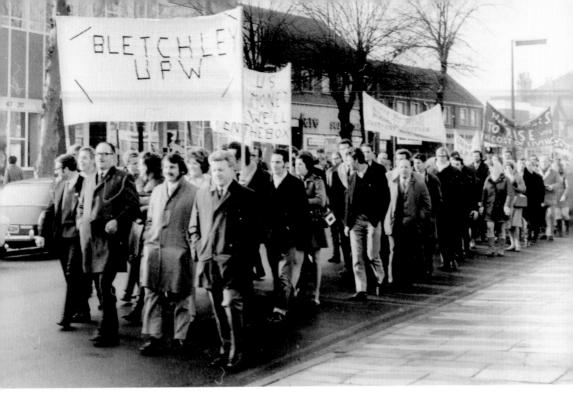

A Bletchley March and a Caldecotte Run

Turbulent times for the Union of Post Office Workers (UPW) culminated in 1971 in the largest national strike in Post Office history — six and a half weeks — estimated to have cost millions in lost revenue. Long-term consequences resulted in the Post Office ceasing to be a government department and being stripped of its telecommunications functions (privatised as BT in 1984). Now, processions in Milton Keynes — as elsewhere in modern Britain — tend to be sponsored runs, hosted in the city's parks.

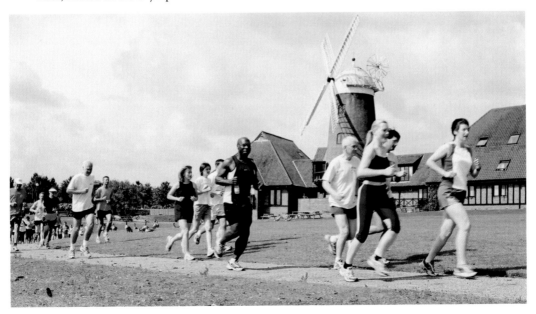

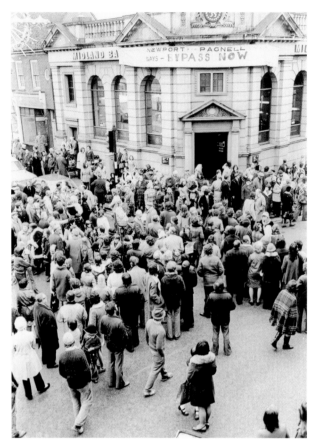

Newport Pagnell, Tickford Street Junction, 1979 and 1900
In 1980 Newport Pagnell's bypass was built following a campaign (left) to rid the town of traffic congestion. Milton Keynes' Master Plan was at pains for residents never to have to suffer such problems. '*The unique grid system of new roads,*' it said, '*offers easy flow of traffic.*' Each grid-square had only local traffic for zoned businesses, with higher-speed through-traffic travelling along surrounding grid roads. '*People do not have to live cheek-by-jowl with huge warehouses, workshops, busy offices and shops.*'

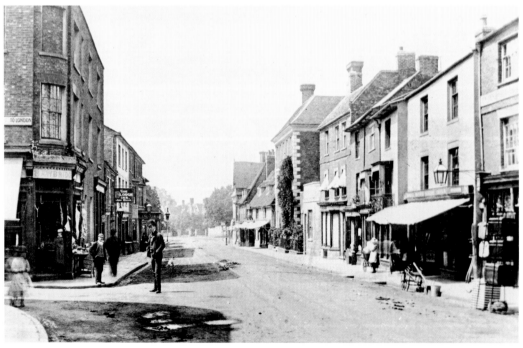

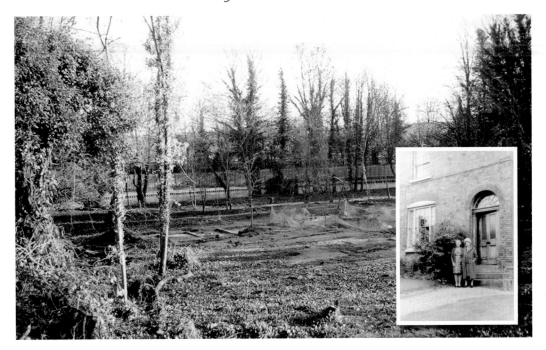

The Secret Garden, Wolverton

Alongside the Grand Union Canal in Wolverton (see the blue barge, centre below), local people have transformed derelict land into a new green space 'for the enjoyment of all of the community' called the Secret Garden. The site was formerly occupied by four semi-detached villas, built by the London & Birmingham Railway Company *c.* 1840s for managers of the Railway Works. Designed in consultation with local people, the garden has won many awards, including the Queen's Award for Voluntary Service.

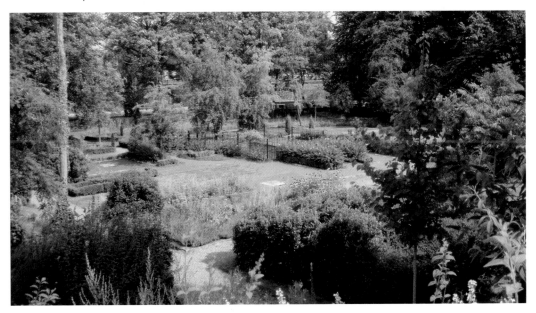

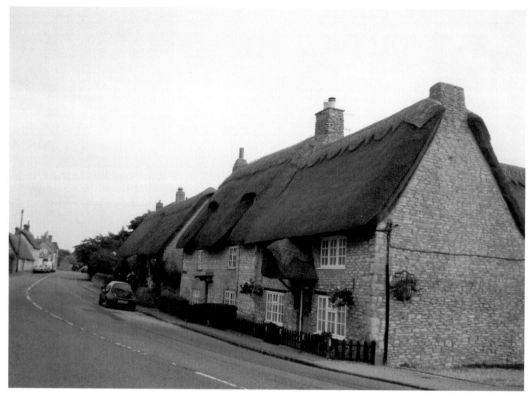

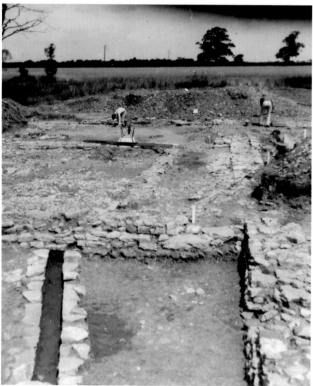

Stoke Goldington

Stoke Goldington is a typical North Buckinghamshire village with thatched, light-coloured stone houses. They line a main eighteenth-century coaching route — when the village had seven inns. The stagecoaches have disappeared, and although High Street buildings seem little changed (above) just west of the village is the lost community of Gorefields. A 1969 excavation (below) uncovered ruins of a Cluniac Nunnery on an ancient moated Norman Hall, built *c.* 1100, with Saxon pottery finds of 900 years earlier.

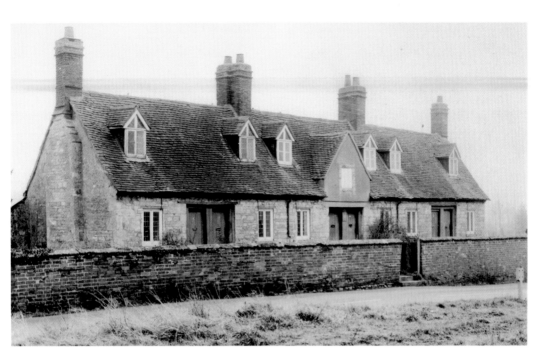

Shenley Church End Almshouses

Shenley means 'bright clearing' in Old English, known as *Senelai* in the 1086 Domesday Book. Thomas Stafford of Tattenhoe founded the almshouses in Shenley Church End (1654), pictured here, in memory of his father, for two women and four men — 'The Poor People of Stafford's Hospital in Shenley'. In 2006, a one-bedroom house here with its 'wood-burning stove, vaulted ceilings, exposed beams and wooden floorboards' was on sale for £139,995 (article in the *Independent*).

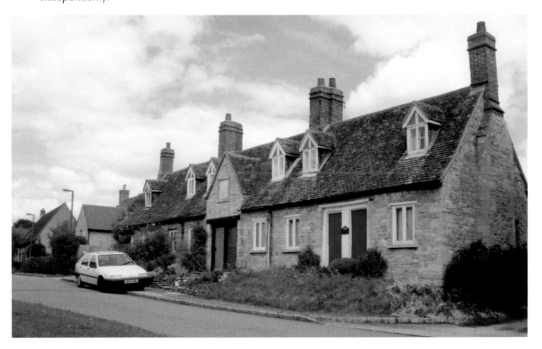

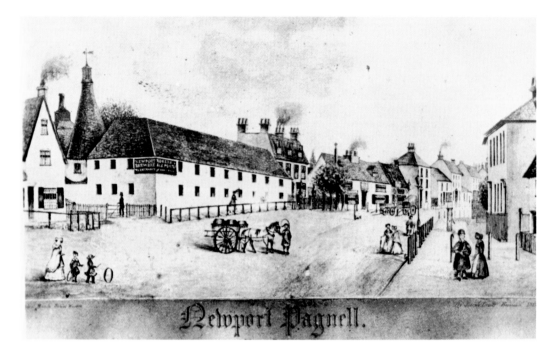

Newport Pagnell.

Newport Brewery to Medical Centre

The Newport Brewery (anonymous 1852 painting above) was built in 1780 by Thomas Meacher who lived in the Brewery House, with its Queen Anne shell porch, beside the modern Dolphin pub. The business changed hands five times but remained a brewery until the early 1900s. It lay derelict until Cooper's agricultural business took it over in 1924, still with its malting chimney. Sold in 1991, the site was demolished and rebuilt in 1994 as the Newport Pagnell Medical Centre (below).

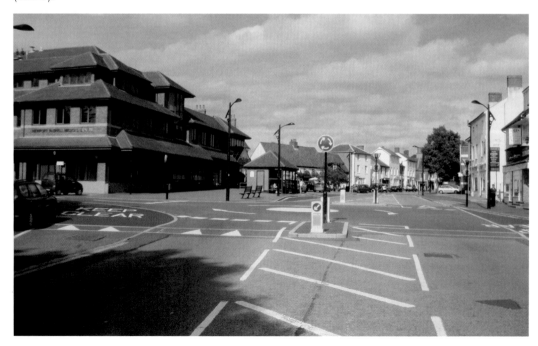

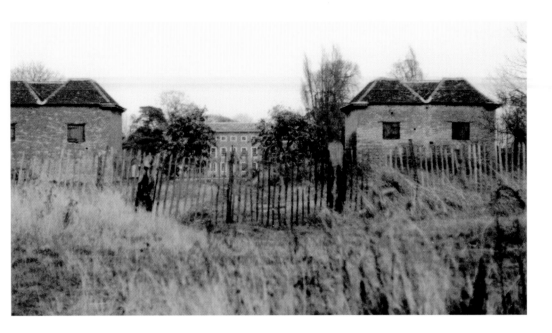

Great Linford Manor House and Pavilions

The Uthwatts inherited Great Linford Manor House in the mid-eighteenth century, extending the house with 'various tricks to emphasise the manor's impressive and elegant appearance', like the two stone-built pavilions opposite the manor being designed to look like houses but actually functioning as stables. In front of the manor, a tree-lined track led to descending water-gardens. A sorry sight in the 1970s, the house and pavilions have been transformed to be the centre of many community arts activities.

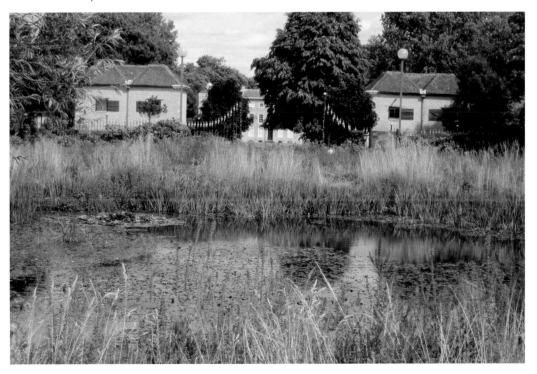

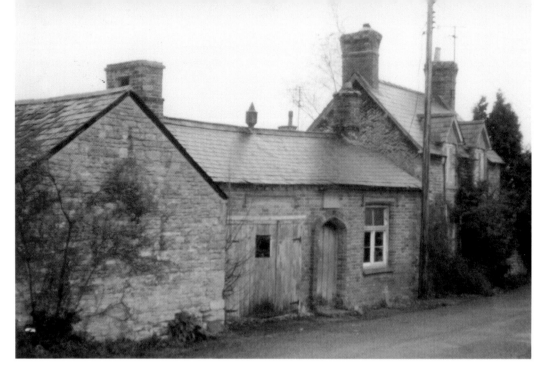

The Former Clifton Reynes Parochial School

Clifton Reynes takes its name from the village's high position on a bank (*'clif'*) of the River Great Ouse and from its ancient lords of the manor. The Clifton Reynes Parochial School, built in 1844, had become a garage for a 'working village' by the 1970s and, according to one long-term resident, was run by Tom Pomfrey who also lived in the other half of the building. The school house eventually enjoyed sensitive refurbishment as a private residence, as seen below.

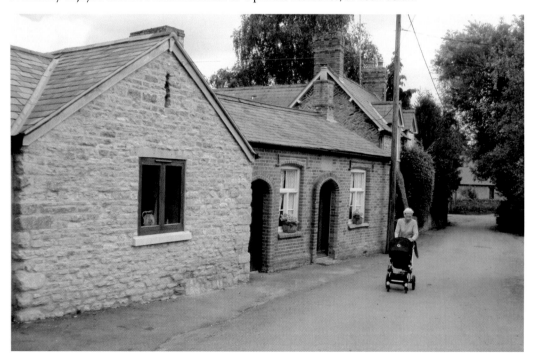

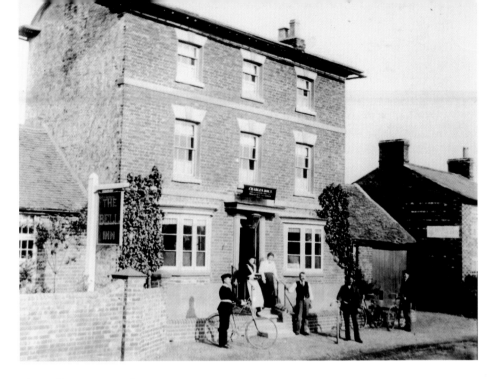

The Bell Inn at Loughton

Charles Holt, the founder of a local charity, was proprietor of the Bell Inn (above) at the turn of the century, with William Wesley listed as owning the inn in 1915. Arthur Freegard ran it until the 1940s, but in 1948 the Bell Inn was demolished and reportedly replaced with two bungalows. These too were replaced with a new set of homes (below) still alongside the building (right) with its distinctive chimneys — then advertising 'Humber cycles' and now a private residence.

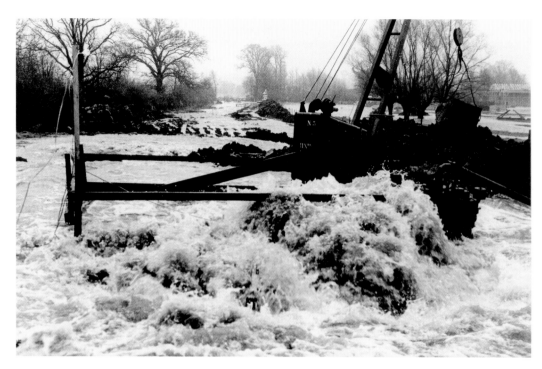

Canal Burst at Simpson, Canal-side Living at Fenny Stratford

The section of the Grand Union Canal crossing Milton Keynes is its longest — ten miles — without any locks. In December 1971, part also became waterless. Brian O'Sullivan recalls:

We were digging this manhole shaft in Simpson, about 6m in diameter, 10m down, when we hit rock. We put explosives in. Then... Whooooomft! There were bits of ladder, everything came flying out and everyone was running like mad. The shaft started filling up with water, right up to the top...

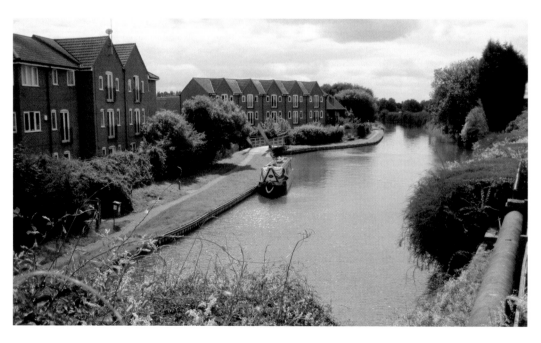

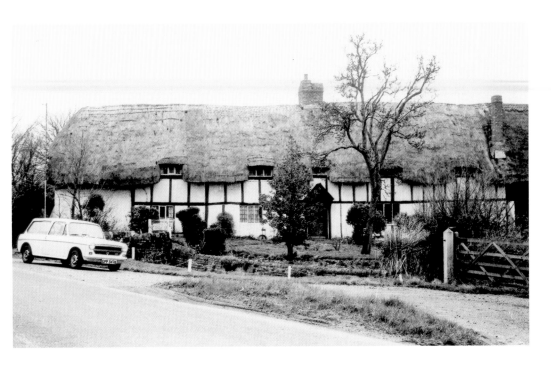

Caldecotte Cottage

This seventeenth-century thatched and half-timber building at Caldecotte did not survive its fire in the 1980s. Sue Malleson remembers it as '*a splendid low thatched cottage... Opposite is a meadow, the site of the "shrunken medieval village" of Caldicot. It has not been, and presumably never will be, built upon — acknowledged as a site of importance when modern Milton Keynes was surveyed.*' The view below is of the pond believed to be close to the cottage site.

Coffee Hall — From Field to Community Centre

As with most of the designated city area, the land to be developed (above) was agricultural. Now located between the new-city estates of Leadenhall, Eaglestone, Netherfield and Beanhill, Coffee Hall is just south of Central Milton Keynes. Its name comes from the farm once adjacent to a lane from Woughton on the Green. The new estate's typical purpose-built Community Centre (below) has disabled and self-catering facilities, with space for '140 seated, 90 dancing... from £3 to £12 for an hour's hire'.

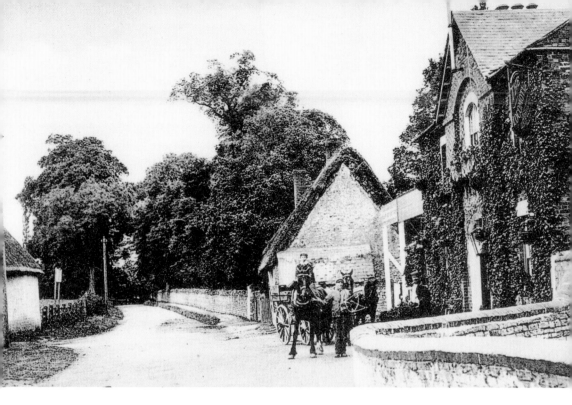

Old Wolverton Wharf's Canal-side Pub

Originally The Wharf House, this 200-year-old canal-side pub was renamed The Locomotive Hotel — 'The Loco' — when the railway arrived and then The Galleon in 1939. Behind it is Old Wolverton Wharf where canal freight was loaded to and from the nearby turnpike. Eighty years ago Herbert Hickman ran his timber and builders' business here, followed by traders like Roberts and Wilsons, Jewsons and now Frazer; the pub is again in transition, awaiting new owners to open up.

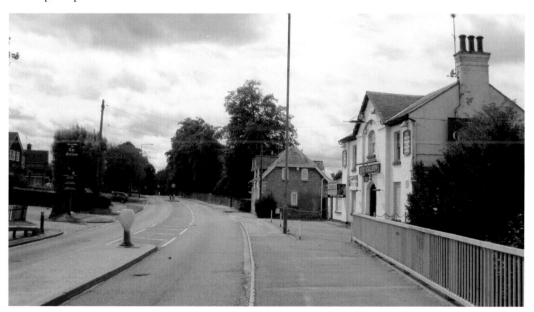

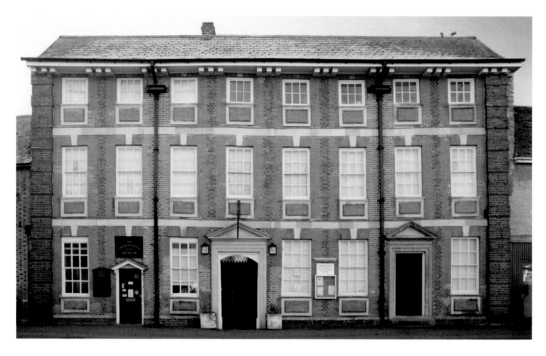

The Cowper and Newton Museum

Famous for their *Olney Hymns*, William Cowper and John Newton are commemorated by this wonderful museum — the oldest in the borough. John Newton, author of the hymn *Amazing Grace*, was curate of Olney and is buried there. His guest was William Cowper (poet and hymnodist, 1731-1800). The museum was Cowper's own residence and was given to the town in 1905 by the publisher William Hill Collingridge, who had himself been born in the house, with Thomas Wright its first passionate custodian.

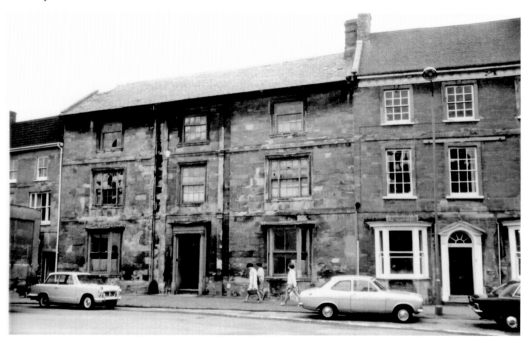

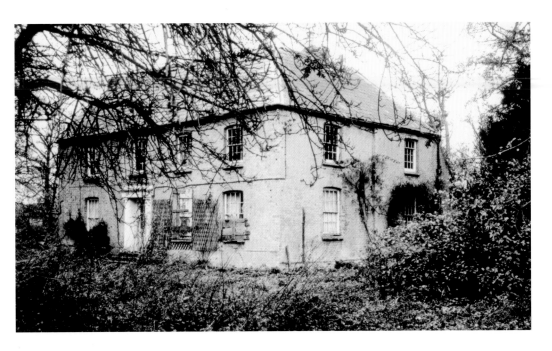

The Old Rectory Farmhouse — Inter-Action MK 2009

On the site of a scheduled ancient monument — a seventeenth-century moat and fishpond of a long-gone mansion — Old Rectory Farm was deserted and dilapidated by the 1970s. As one of the many community organisations pump-primed by Milton Keynes Development Corporation, Inter-Action made its home there after the Corporation acquired the property. Over thirty years later, its base is refurbished and its aims include delivering 'a programme of high quality... inclusive Community Arts' and maintaining the Old Rectory 'as a welcoming, interactive and popular arts venue'.

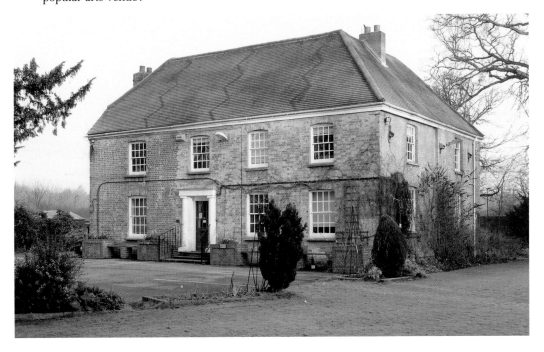

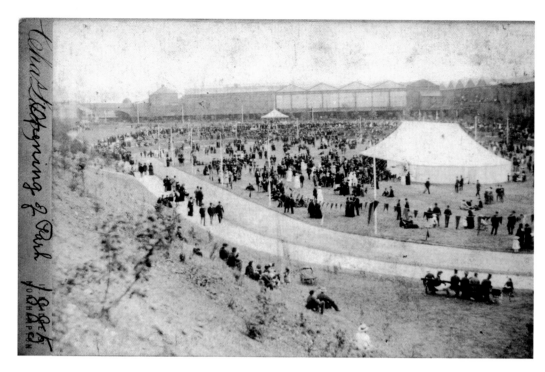

Wolverton Park

On 3 August 1885, Wolverton Park opened as Wolverton's new recreation ground. Thereafter, an annual celebration was held with processions, bands, cyclists, runners, footballers, tennis-players, dances and fireworks. Wolverton Park also hosted Wolverton Football Club — which from 1887 became one of the leading teams of the country playing Tottenham, Chelsea and Crewe Alexander. Now Wolverton Park has been redeveloped as canal-side apartments, with the former Royal Train shed transformed into housing and the sports field into a public garden.

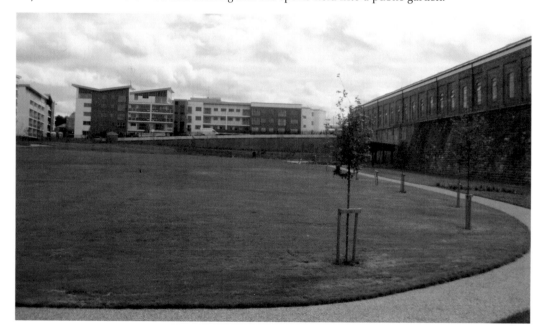

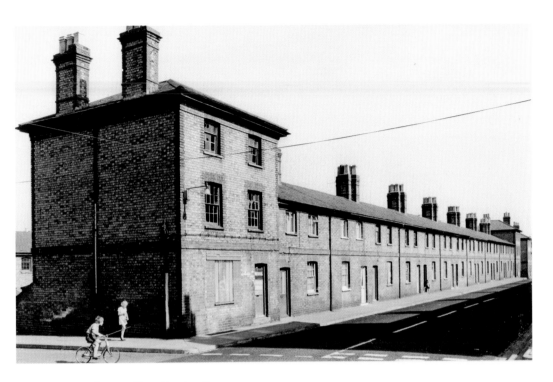

Spencer Street, New Bradwell

Threatened by demolition in the 1960s, like other New Bradwell railway cottages as well as Wolverton's 'little streets', these in Spencer Street were listed Grade III by the Department of Environment and restored by Milton Keynes Development Corporation in 1978, to be run by a housing co-operative. Originally running parallel to the full length of the High Street, and pedestrianised, Spencer Street today is all but hidden by leafy trees and shrubs.

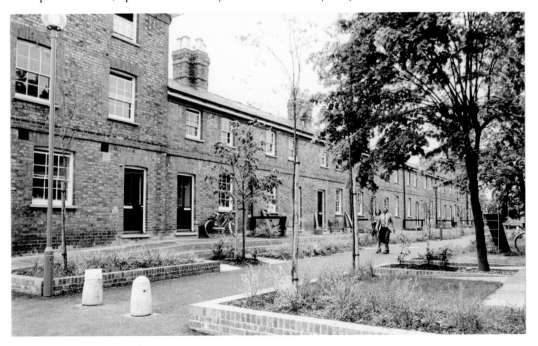

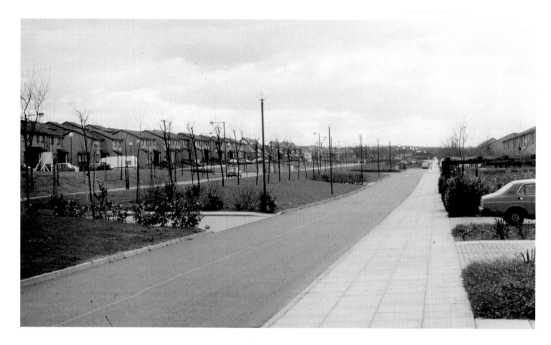

Downs Barn Boulevard 1970s and 2009

Downs Barn Boulevard is a long, straight, tree-lined residential road typical of housing estates around Central Milton Keynes. It is named after ancient agricultural buildings, referred to as 'Horse Ground' on a seventeenth-century Great Linford map, with its street names linked to horses. However, inhabitants were in the area 2,500 years ago — county archaeologists identified 'late Iron Age features' here. Downs Barn currently hosts a new woodland trail, transformed in 2008 by the BBC's *Springwatch* Action Team.

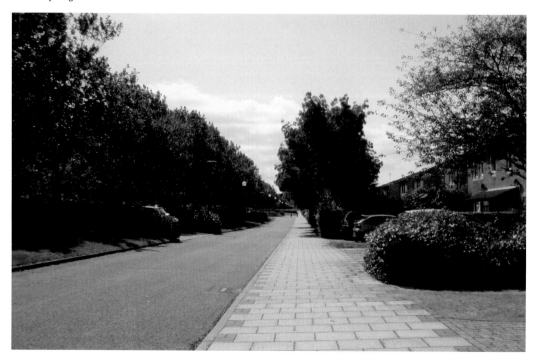

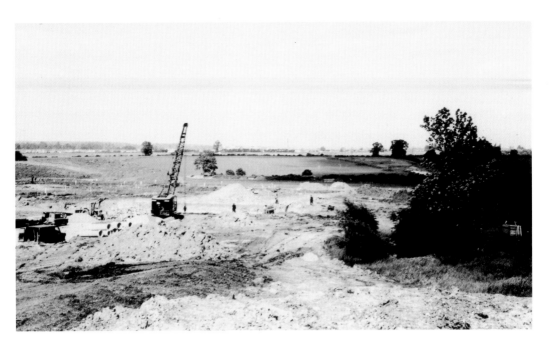

Fullers Slade

Referring to rural forebears, Fullers Slade, named on the Wolverton map of 1742, recalls the fuller's trade — where cloth was trodden or beaten to cleanse and thicken it — and where it took place — in a woodland glade. The photograph above had enormous significance for the designated new city of Milton Keynes, showing construction of its first grid road — H2 Millers Way. The estate itself (below) was considered 'an architectural showpiece' with 'single sloped roofs, criss-cross cedar cladding and tiny gardens'.

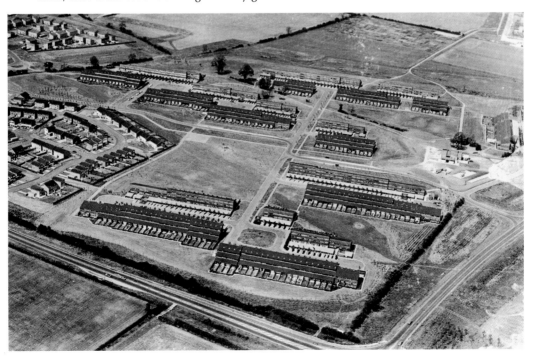

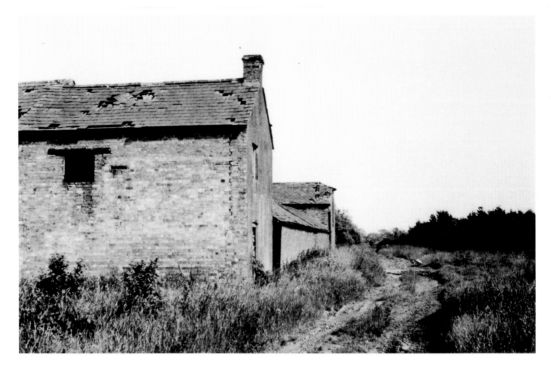

Milton Keynes City Centre in 1971 and 2006

'We'd got quite a nice herd of dairy Shorthorns and about 130 acres. There was Cricket Field, Shouler's Field and Newport Two Stiles... The land was in a terrible condition. Scatteralls was one mass of anthills...' John Morris, tenant farmer on land that is now Central Milton Keynes, was bitter about 'being kicked out'. But another, David Bodley says, *'We wouldn't be where we are today financially if it wasn't for Milton Keynes, so we can't really knock it can we?'*

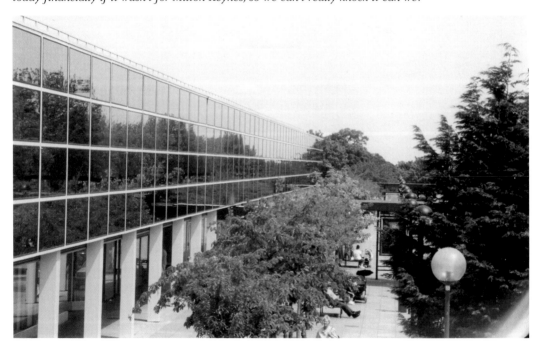